# Sardine

Animal
Series editor: Jonathan Burt

*Already published*

*Albatross* Graham Barwell · *Ant* Charlotte Sleigh · *Ape* John Sorenson · *Badger* Daniel Heath Justice
*Bat* Tessa Laird · *Bear* Robert E. Bieder · *Beaver* Rachel Poliquin · *Bedbug* Klaus Reinhardt
*Bee* Claire Preston · *Beetle* Adam Dodd · *Bison* Desmond Morris · *Camel* Robert Irwin
*Cat* Katharine M. Rogers · *Chicken* Annie Potts · *Cockroach* Marion Copeland · *Cow* Hannah Velten
*Crocodile* Dan Wylie · *Crow* Boria Sax · *Deer* John Fletcher · *Dog* Susan McHugh · *Dolphin* Alan Rauch
*Donkey* Jill Bough · *Duck* Victoria de Rijke · *Eagle* Janine Rogers · *Eel* Richard Schweid
*Elephant* Dan Wylie · *Falcon* Helen Macdonald · *Flamingo* Caitlin R. Kight · *Fly* Steven Connor
*Fox* Martin Wallen · *Frog* Charlotte Sleigh · *Giraffe* Edgar Williams · *Goat* Joy Hinson
*Gorilla* Ted Gott and Kathryn Weir · *Guinea Pig* Dorothy Yamamoto · *Hare* Simon Carnell
*Hedgehog* Hugh Warwick · *Hippopotamus* Edgar Williams · *Horse* Elaine Walker · *Hyena* Mikita Brottman
*Kangaroo* John Simons · *Leech* Robert G. W. Kirk and Neil Pemberton · *Leopard* Desmond Morris
*Lion* Deirdre Jackson · *Lizard* Boria Sax · *Llama* Helen Cowie · *Lobster* Richard J. Kin
*Monkey* Desmond Morris · *Moose* Kevin Jackson · *Mosquito* Richard Jones · *Moth* Matthew Gandy
*Mouse* Georgie Carroll · *Octopus* Richard Schweid · *Ostrich* Edgar Williams · *Otter* Daniel Allen
*Owl* Desmond Morris · *Oyster* Rebecca Stott · *Parrot* Paul Carter · *Peacock* Christine E. Jackson
*Penguin* Stephen Martin · *Pig* Brett Mizelle · *Pigeon* Barbara Allen · *Rabbit* Victoria Dickenson
*Rat* Jonathan Burt · *Rhinoceros* Kelly Enright · *Salmon* Peter Coates · *Sardine* Trevor Day
*Scorpion* Louise M. Pryke · *Seal* Victoria Dickenson · *Shark* Dean Crawford · *Sheep* Philip Armstrong
*Skunk* Alyce Miller · *Snail* Peter Williams · *Snake* Drake Stutesman · *Sparrow* Kim Todd
*Spider* Katarzyna and Sergiusz Michalski · *Swallow* Angela Turner · *Swan* Peter Young
*Tiger* Susie Green · *Tortoise* Peter Young · *Trout* James Owen · *Vulture* Thom van Dooren
*Walrus* John Miller and Louise Miller · *Whale* Joe Roman · *Wild Boar* Dorothy Yamamoto
*Wolf* Garry Marvin · *Woodpecker* Gerard Gorman · *Zebra* Christopher Plumb and Samuel Shaw

# Sardine

Trevor Day

REAKTION BOOKS

Published by
REAKTION BOOKS LTD
Unit 32, Waterside
44–48 Wharf Road
London N1 7UX, UK
www.reaktionbooks.co.uk

First published 2018
Copyright © Trevor Day 2018

Printed and bound in China by 1010 Printing International Ltd

A catalogue record for this book is available from the British Library

ISBN 978 1 78023 996 5

# Contents

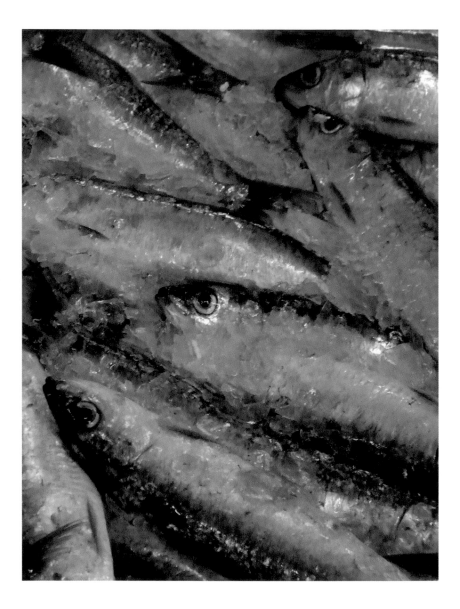

# Introduction

It is early evening in midwinter, on the shore of Mount's Bay, Cornwall, England. To my left is the brooding presence of St Michael's Mount, a craggy mound offshore. Perched atop is the shadowy outline of a turreted stately home, formerly a Benedictine monastery. Ahead, several hundred metres away, five clusters of orange lights dance gracefully across the sea surface, arcing and swaying. They are five fishing boats engaged in a Cornish rite that has been re-enacted over at least seven centuries. They are hunting down European sardines (*Sardina pilchardus*). The technology might be modern but the process is essentially the same. Find a shoal of sardines, encircle or ensnare them with a net, close off their escape and then haul the fish on board.

It is tough, dangerous, skilled work. On this particular day, the fleet of five vessels ranges from 10 m to 15 m long, with crews of three or four. On board the *Pride of Cornwall*, the smallest vessel, skipper Danny Downing is using his 'searchlight' sonar to find the telltale red traces on the sonar display of fish about 200 m ahead. Sardines rise near the surface at night and they are catchable if they swim over a smooth, shallow seabed that will not snag the net.

It is a delicate art, deciding from the sonar's display the type and size of fish, and in which direction they are heading. The trick is not to ride over the fish, scattering them, but to have them in

Fresh-caught European sardines in a market in Lisbon, Portugal.

your sonar sights and to shoot the several-hundred-metre-long net around the fish. Once they are completely encircled, the bottom of the net is drawn tight and one end is hauled back to the boat, bringing the net alongside in what is effectively a giant pocket. Within, the thrashing fish rise to the surface in a frothing frenzy. A crew member plunges a cup-shaped brailer net into the mass, hauling out a few hundred fish at a time and emptying them into the boat's hold. There, ice mixed with seawater chills the fish to rapid quiescence.

On this particular night, in about three hours, the *Pride of Cornwall* catches 5.5 tonnes of fish.[1] On returning to Newlyn harbour, downloading the catch – one brailer-full at a time – takes at least two hours. The crew pour batches of fish into large plastic crates, mix them with ice and seawater, and bang the lids shut. The skipper manoeuvres a forklift truck at speed, collecting empty crates and stacking the fish-filled ones for loading onto refrigerated lorries. The destinations of the fish are tens to hundreds of kilometres away.

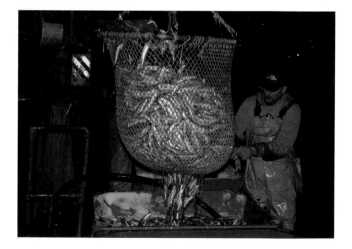

Cornish sardines being emptied from a brailer net into a crate for transportation.

At about £300 a tonne, this catch might realize £1,650, of which more than half will go to cover the boat's operating and capital costs. The price of the fish varies depending on quality and demand. The largest, best-quality fish make their way to supermarkets as fresh, whole fish. Some are canned and the smaller, poorer-quality ones are supplied to zoos as animal feed.

The fishermen work into the night. Well before dawn, they will go out again, hunting more sardines before daybreak. When the weather is fair, they make the most of the opportunity, working every day for up to three weeks. Bad weather halts fishing and good times need to cover the cost of the bad.

What is happening in Newlyn is a microcosm of what is happening across the world. Hunters go out to intercept fish and bring in a catch with a value that depends on supply and demand and the caprices of culinary fashion. Sardine fishermen are

A typical, modern Cornish seiner. As elsewhere in the world, such boats fish for sardines at night, when the fish rise close to the surface in shallow water.

opportunistic. Depending where they are fishing across the world, when not catching sardines they may turn to herring, pollack, anchovies or squid – seafood that is legal, for which there is a demand, and that will cover their operating costs and pay wages.

The earliest known written reference to a sardine is probably in Aristotle's *History of Animals* from around 350 BCE.[2] According to the nineteenth-century French natural historian Georges Cuvier,[3] and modern scholars tend to agree with him, the fish Aristotle refers to as *membras, trichis* or *trichias* – the same species but at different ages and sizes – is almost certainly the European sardine (*Sardina pilchardus*). This fish was abundant in northern Mediterranean waters, and in classical Roman times was salted and transported in amphorae. It was a relatively cheap fish but found its way into expensive fish sauces such as the fermented condiment *garum*. Preserved fish bones reveal Roman merchants transporting salted European sardines and round sardinella (*Sardinella aurita*) as far north as Belgium by the third century CE.[4]

According to the food historian Maguelonne Toussaint-Samat, *sardine* derives from Roman names for the fish, such as *sardina*, and its name is inextricably linked with the island of Sardinia, where it was once caught in abundance.[5] The Greek *sardinos* also refers to a small fish of silvery appearance. Then, as now, what exactly a sardine is could become blurred. In a Roman cookbook ascribed to Apicius from the first century CE, but with recipes not collected and published until several centuries later, a fish

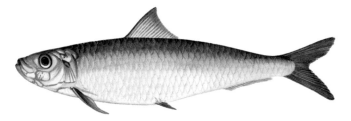

The European sardine or pilchard, *Sardina pilchardus*, is common in the northeast Atlantic and in adjacent seas.

'omelette' is described made with wine and oil, with an accompanying wine sauce.[6] Sardine is the main ingredient but Apicius could be referring to a European sardine, a round sardinella, sprats or anchovies, or a mixture of them.

By medieval times, European sardines were being caught in abundance off Brittany and France, along the Moroccan coast south of Portugal, and as far north as England and Ireland. In England the European sardine was called a pilchard, with the first reference to it found in customs records from the 1340s.[7] According to the *Oxford English Dictionary*, the etymological roots of the word 'pilchard' are unknown, although the name first emerged in northern Europe.

So, deciding what is and is not a sardine is not straightforward. Hundreds of species of marine fish are small, slender and silvery. In his *History of Animals* and subsequent ichthyological publications, the pioneering sixteenth-century natural historian Conrad Gessner did an exemplary job, distinguishing several European herring-like species, both in text and in woodcut illustrations.[8] In a modern review of Gessner's work, Sophia Hendrikx relates:

> Gessner identifies a group of species which due to their similarity are difficult to tell apart. In addition to the herring, this group includes the Allis shad, the Twaite shad, and the sardine. Gessner describes these species as having silvery scales and black and blue colouring on their backs, lighter keels with a row of sharp scales, and scales that can be quite easily removed. In addition, he states they have similar shapes and similar flavours, as well as similar intestines.[9]

And further:

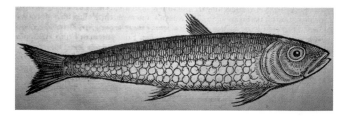

An early image of a European sardine, *Sardina pilchardus*. Woodcut from Conrad Gessner's *Historiae animalium* (1558). The large scales distinguish it from similar local species such as the round sardinella, *Sardinella aurita*.

The sardine is described as smaller than the herring but otherwise quite similar, with light scales that are easily removed, blue and green colouring on the back, spots on its back, and a row of hard scales on its keel, sharper than those of the herring.[10]

A sardine fresh from the sea is a silvery gem, its back shimmering with iridescent blues and greens.

Today, the herring family, traditionally called the Clupeidae, contains some 190 such species, including herring, menhaden, sprats, anchovies and sardines.[11] These so-called clupeid fish are small; the biggest is 60 cm long, with most growing to less than 30 cm. Like most fast-swimming fish, they have streamlined slender bodies with rounded heads and tapering tails. To pin down what a clupeid fish is, we need to consider technical information about its physical characteristics.

Japanese drawing styles are rather different to European, as in this depiction of a Japanese sardine, at the time called *Clupea melanosticta*. From Philipp Franz von Siebold's 1840s compilation of fishes in *Fauna Japonica*.

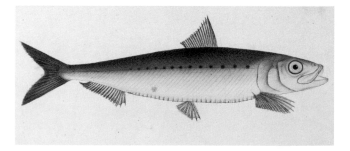

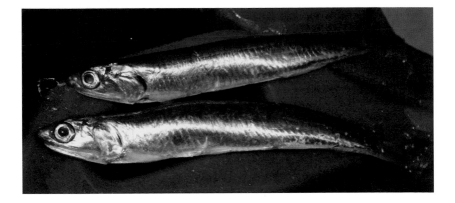

The head of a clupeid fish lacks scales. The lateral line – a row of sensory structures opening visibly onto the body surface as small pits – is restricted to the sides of the head and does not extend along the flanks as in most fish. Much of the body is covered in silvery, circular, smooth-edged scales. In clupeid fish an air-filled sac inside the abdomen extends forwards and connects to the inner ears. These and other diagnostic features distinguish clupeid fish from others.[12] The sardine is easy to confuse with some other species of small clupeid. Size for size, however, a sardine has larger scales than a small herring, while an anchovy has a bigger mouth that extends beneath the eye. But, as to which of the clupeid species is actually a sardine, it depends to whom you speak.

The Food and Agricultural Organization of the United Nations (FAO) has for several decades decided that three subgroups, or genera, of the herring family qualify as sardines: *Sardina*, *Sardinops* and *Sardinella*. These amount to between 21 and 24 species; exactly how many depends on which authority you consult.

Some have cast a wider net, at various times in various places saying that other sardine-like species, and even juvenile herring, are sardines. Fishbase, the Global Information System on Fishes

The European anchovy, *Engraulis encrasicolus*. With its large mouth, typical of anchovies, it is quite distinct from any sardine.

with contributors from dozens of countries, lists more than thirty species of fish that are identified as sardines somewhere in the world. If variants of the popular name *Sardinella* are added to this, the number rises to more than ninety candidates.[13] On the East Coast of the United States, a thriving industry grew up around catching and canning small herring. Today this commerce is celebrated at the Maine Coast Sardine History Museum.[14] What Norwegians call a sardine is a European sprat or brisling (*Sprattus sprattus*), as featured in the Norwegian Canning Museum in Stavanger.[15] These museums celebrate fish that are not the subject of this book. But even restricting ourselves to what many biologists regard as true sardines (members of *Sardina*, *Sardinops* and *Sardinella*), there is, as we have seen, a common alternative name for a sardine.

In the Americas, Europe and beyond, fishermen, fish biologists, fish-sellers and the general public sometimes use the term 'pilchard' instead of 'sardine'. Which word is preferred goes in and out of favour. In Europe until recently, the term 'sardine' was usually reserved for smaller individuals (less than 15 cm unprocessed, or 10 cm when processed, with head and guts removed). If the fish were longer than this, it was a pilchard. In Britain the European sardines caught off Cornwall and Devon were for centuries called pilchards. They are now, irrespective of size, sold under the upmarket moniker Cornish sardines, and with a protected regional designation. In this book I use 'sardine' or 'pilchard' where it best fits culturally and historically, knowing that for all intents and purposes they are common names for the same fish.

Having satisfied ourselves as to what a sardine is and is not, we can begin to consider its lifestyle. Sardines tend to swim within 200 m of the sea surface. They can travel in shoals of astonishing size, reaching more than 16 km long and 5 km wide and containing

hundreds of millions of fish. They are concentrated in specific places across the ocean, being found in the greatest numbers in temperate waters where deep, cold, nutrient-laden water rises to the surface. In such places, called upwellings, the combination of available nutrients and sunlight fuels the rapid growth and multiplication of microscopic, drifting, plant-like organisms – phytoplankton (plant plankton). Phytoplankton are eaten by drifting animals – zooplankton – and they, in turn, are eaten by larger, actively swimming animals, including sardines. Sardines are opportunistic. They feed on phytoplankton or zooplankton, or both, depending on which is abundant at the time.

Sardines are then eaten by a host of other animals. Depending on location, predators can be fish, including mackerel, tuna, sharks and billfish such as marlin; birds, among them gannets, gulls, albatrosses, pelicans and cormorants; or mammals, such as seals, sea lions, dolphins, porpoises and whales. When sardines rise near the sea surface at night to feed on plankton, this makes them comparatively easy to catch by people using seine nets that encircle all or part of a shoal. All manner of fish-catching devices have been used in the past, including anchored walls of netting (gill nets), drifting walls (drift nets), enclosing seine nets, and netting set at right angles to the shore, guiding fish to ingenious traps. Several of these techniques are described and illustrated in the work of the eighteenth-century French polymath Henri-Louis Duhamel du Monceau.[16] Until the beginning of the twentieth century, the French used a technique not found elsewhere – scattering fish eggs into the water to attract sardines, which then entangled themselves in drift nets deployed alongside. Even without attractants, at their most crazily abundant you can stand on a beach or in shallow water, scooping out sardines with a shoe or bucket. People used to do this in Cornwall and still do today in KwaZulu-Natal, South Africa.

Sardines are secondary consumers that eat primary consumers (zooplankton) and primary producers (phytoplankton). Sardines, in turn, are eaten by tertiary consumers such as tuna, and quarternary consumers such as sharks.

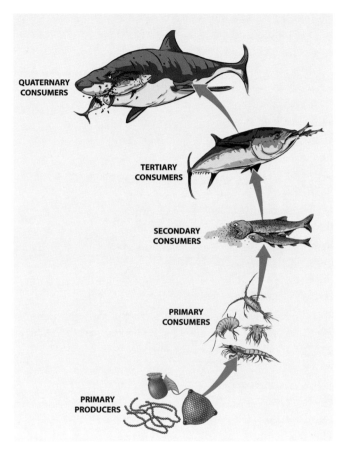

In 1971 British fisheries biologist Michael Culley published *The Pilchard: Biology and Exploitation*, summarizing some of the then-known information about sardines across the world. In his book Culley included a map showing global sardine distribution based on the conclusions of a meeting of scientists organized by the FAO in the late 1950s.[17] This map was complex, showing the

distributions of seventeen sardine species, some overlapping, variously stretching from Scandinavia in the north to Australasia in the south, and across the Atlantic, Indian and Pacific Oceans. Then, as now, little scientific and commercial data was collected about some *Sardinella* species, including those caught in some coastal regions of the Middle East, Bangladesh and India, and around islands in the South Pacific. The eighteen-plus species of *Sardinella* are distributed across the tropical waters of the Atlantic and Indian Oceans and in the western Pacific. One species, *Sardinella tawilis*, even lives in fresh water – in a lake in the Philippines.[18]

The main focus of this book, as of large scientific studies, is on the *Sardina* and *Sardinops* sardines from five upwelling regions: the Benguela Current (off South Africa and Namibia); the California Current (off the western United States, Canada and Mexico); the European and North African Atlantic (including Morocco, France, Portugal, Spain and the UK); the Humboldt Current (Chile and Peru); and the Kuroshio-Oyashio Region (around Japan).[19] The Pacific sardine (*Sardinops sagax*) is found in three of these upwelling regions – around Namibia and South Africa, and the west coasts of South and North America – as well as off Australasia. Until the late 1980s, these populations were regarded as four separate species. Biochemical comparison now reveals that the fish are sufficiently similar to be given single-species status.[20] The four have been reduced to the one pedestrian label Pacific sardine (*Sardinops sagax*). This is despite South African sardines living in the Atlantic and Indian Oceans, and despite regional differences in size, shape and colouration. South African sardines tend to have fewer spots on their flanks than their South American brethren. The Japanese sardine is a separate *Sardinops* species (*Sardinops melanostictus*) – shorter but fatter than the Pacific sardine.

As for the European sardine or pilchard (*Sardina pilchardus*), it is bigger-scaled and larger-eyed than its *Sardinops* cousins. It is widespread in northeast Atlantic coastal waters, from the North Sea to the Mediterranean and as far south as Senegal in northwest Africa.

Centuries after the pioneering work of natural historians Conrad Gessner and Georges Cuvier, the evolutionary relationships of sardines and their taxonomic classification into families, genera and species are still contested. This is the case for many types of fish, not just sardines. Biological classifications change as scientists gather fresh evidence. One recent reclassification of

Californian sardines, a subspecies of the Pacific sardine, *Sardinops sagax*, have bolder spots and smaller eyes and scales than the European sardine, *Sardina pilchardus*.

herring, sardines, anchovies and their close relatives – based on biochemical and genetic evidence – no longer talks of the family Clupeidae, but sees *Sardina* and *Sardinops* in a separate family from *Sardinella*.[21] But before we get lost in this taxonomic tangle, we need to remind ourselves of the importance of sardines – socially and economically.

The cultural and economic significance of sardines, from classical times to the present day, is closely interwoven with the means of catching, preserving and cooking them. Across cultures their status has shifted repeatedly, from peasant food to gastronomic delicacy, rocked by the fickleness of culinary fashion and dramatic changes in natural supply. All the while, there has been an inexorable evolution in both fish-catching and fish-processing methods, which means that sardines can now be caught and processed with unnerving efficiency.

Arguably, more people alive today have eaten a sardine than any other fish. Sardines being found in the three biggest oceans, and being tinned for export or eaten fresh, means that whether you live in London, Lima, Lisbon, Lagos or Los Angeles, Moscow or Melbourne, Oslo or Osaka, you are likely to have seen a sardine or a picture of one even if you have not eaten the fish.

For many centuries, coastal communities have flourished and declined, with their destinies entwined with the local sardines on which they depended. Sardines are part of our collective consciousness, although the word resonates differently across diverse cultures. The fish-loving Japanese call sardines *iwashi* (common fare) and grace them with well over fifty recipes. The paean to the sardine *Le Roman de la sardine* (Romance of the Sardine) contains more than 120 provincial French recipes.[22] Fish connoisseurs on the u.s. East Coast revere fresh sardines imported from Portugal and grill them whole, with minimal preparation. And millions of people are familiar with sardines in cans – as low-price,

convenience food – and talk of the experience of being packed together like sardines when travelling on trains and buses.

Nearly one-third of all fish caught in the ocean by weight is made up of herring-type (clupeid) fishes. In 2014 they realized a global revenue of more than u.s.$3.7 billion.[23] The actual weight of herring-like fish landed, and therefore their total value, is higher than this, because in a region's catch statistics small fish are sometimes lumped together as 'miscellaneous'. In any case, small-scale, artisanal fishing, where the food is distributed and eaten locally, may not appear at all in catch statistics. The importance of these small fish on the world stage is greater than raw economic data suggest. In coastal and near-coastal towns in Africa, Asia and South America sardines and other small fish are a vital source of protein in communities that would otherwise be protein-deficient.

For much of the twentieth century, sardines and anchovies alternated as being the world's largest fish catch of all by weight. In 2014 the global catch of anchovies and sardines was in excess

Young sardines, a Japanese delicacy.

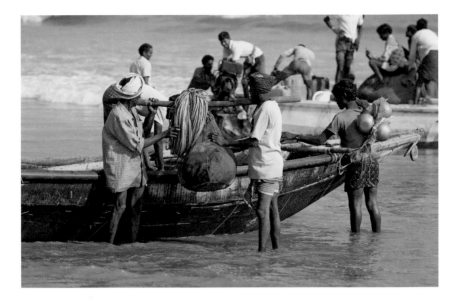

of 5 million tonnes and 3 million tonnes respectively.[24] At the time of writing this book, anchovies held the number one position. But sardines might yet do so again.

Artisanal sardine fishermen in Sri Lanka. Typically, their sardines are dried and eaten locally.

The ubiquity of the sardine means that in order to tell its story, we have to be selective. In this book stories have been chosen from across the sardine's history and geographic range in order to highlight our paradoxical relationship with the fish. On the one hand the sardine is commonplace; on the other, its commercial, scientific and symbolic importance has revealed valuable insights into our relationship with nature.

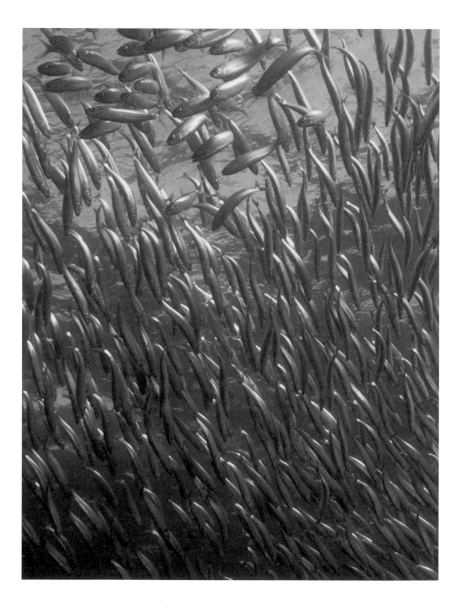

# 1 A Hunted Fish

Below me glide the menacing grey silhouettes of 3-m-long sharks. Whooshing past my shoulder comes a common dolphin, agitated, clicking and whistling, with tail pumping up and down. In front of me is a shimmering ball some 5 m across – a mass of thousands of sardines. It morphs into amoeboid shapes like a diffuse alien from an early *Star Trek* episode. I am 10 m below the surface of the Indian Ocean and a kilometre from the shore of the Eastern Cape, South Africa. I have entered a war zone.

The sardines' smooth movements become jerkier as four dolphins swim around them, corralling them towards the surface. Then the dolphins change tack, scything through the bait ball. The ball unzips as fish scatter just ahead of each dolphin's snout. A dolphin grabs at least one sardine with each pass – often more. This is revealed only when our video footage is played back in slow motion. Meanwhile, menacing bronze whaler sharks are picking off the sardines from below – like the dolphins, grabbing one or more with each pass.

Marauders from above join the melee. Dozens of Cape gannets are dive-bombing the sardines. On their downward trajectory from about 40 m above the sea, they fold their wings, extend their necks, and stretch into an arrow shape, entering the water at about 95 km/h. Plunging to 5 m or so, they chase down individual fish, leaving twisting bubble trails like the contrails of dogfighting aircraft.

A predator's view of a small shoal of sardines as seen from below.

Off South Africa, the smaller sardine bait balls are shed from much larger shoals. They rarely survive more than twenty minutes, being besieged by dolphins, sharks and gannets, and often joined by game fish such as shad and garrick, and, towards South Africa's southerly tip, by Cape fur seals. The sardines scatter and re-form into smaller bait balls, and each is hunted down. Eventually, the sardines are picked off one by one. Every now and then a 15-m-long Bryde's whale will join the party, rising from below with mouth agape to engulf an entire bait ball. Finally, all that is left is the twinkling snowfall of scales shed by beleaguered sardines.

This carnage is part of what the naturalist and TV presenter David Attenborough calls 'the biggest army of predators anywhere on the planet' hunting what might be 'the greatest shoal

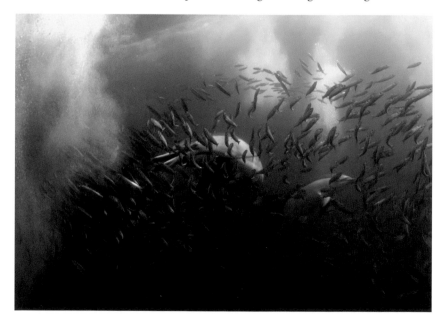

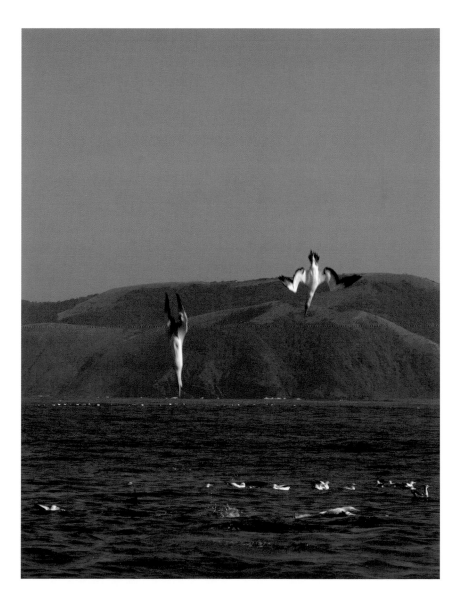

on Earth'.[1] This is the Sardine Run, arguably the world's most astonishing underwater spectacle. I was privileged to experience it at first hand in 2008. Since then, Sardine Runs have not always materialized, with 2013 and 2014 being particularly poor years.

The Sardine Run is caused by a temporary anomaly in most southern winters, when a tongue of cold water becomes trapped alongside South Africa's east coast. Instead of being scattered, the sardines – they favour cool water in the range 14–19°C – gather alongside the coast, becoming a magnet for predators converging from hundreds of kilometres away. If the surface water inshore remains at 20°C or above, as happens in years when the Sardine Run fails to develop, then the cool-loving sardines stay in deeper water. This puts them out of reach of surface predators such as gannets, and makes them harder to catch for sub-surface predators such as dolphins, whales and sharks.

Despite being more than 6,000 km from the Pacific Ocean, South Africa's sardines are nevertheless Pacific sardines (*Sardinops sagax*). Fast-living, most of South Africa's sardines survive for only two or three years and spawn in their second year when 18–20 cm long. Elsewhere, some Pacific sardines live for up to ten years and grow to 35 cm long.[2]

In the southern spring and summer South Africa's sardines gather in billions on and around the Agulhas Banks off the Southern Cape coast. Each adult female releases tens of thousands of eggs into the water, which are fertilized by milt-squirting amorous males. The eggs hatch in a few days and the larvae drift northwards along South Africa's west coast.[3]

The life cycle of South Africa's sardines is governed by two ocean currents. The warm Agulhas Current of the Indian Ocean flows southward down the east coast of South Africa. The chilly Benguela Current from the South Atlantic flows northward up South Africa's west coast. South Africa's two currents meet near

the southern tip, around Cape Agulhas. Here, sea temperatures change dramatically with season, being cold and Benguela-dominated in winter, and warm and Agulhas-governed in summer.

For one- and two-year-old sardines it is better to swim in the cool, nutrient-rich waters off the west coast. This way, the shoals remain fairly dispersed and predators have to travel far and wide to hunt them. However, in many southern winters, the interplay between Benguela and Agulhas currents causes a tongue of cold Benguela water to move more than 1,600 km up South Africa's east coast. With it travels some 10 per cent of the sardine stock, but still amounting to billions of fish. Favouring the cool water, the sardines become hemmed in by the coastline on one side and the warm, southbound Agulhas Current on the other. Most Sardine Run fish are 12.5–20 cm long and make a relatively easy-to-catch, nutritious feast. Perhaps half never return to the Agulhas Banks, but find their way into predators' stomachs.[4]

Such is the importance of the seasonal sardine abundance that at least two predators time their breeding to coincide with it.[5] In summer on Bird Island, some 60 km east of Port Elizabeth, about 80,000 pairs of breeding Cape gannets each nurture a single chick. The steadfast couples, often remaining pair-bonded for life, can recognize each other and their chick among all the others on the rocky outcrop. The hatchlings – blind, naked and weighing only about 70 g – take just eight weeks to become heavier than their parents, fattened by an oil-rich diet of sardines and other small fish caught and regurgitated by their parents. After a further six weeks the young gannets are ready to fly. By June, the parents, soon followed by the fledglings, head northwards to intercept the schools of sardines hugging the coastline.

Meanwhile, pregnant common dolphins in the vicinity of the Southeastern Cape have given birth to single calves. Suckled for six months, the calves are weaned by the start of the Sardine Run.

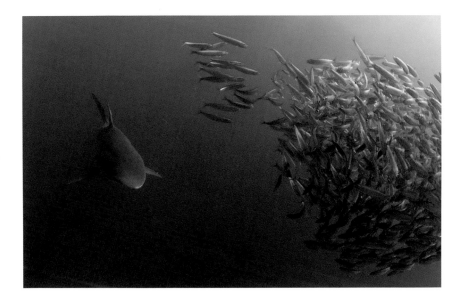

Sardines move away from a shark at the Sardine Run, off South Africa.

Such is the abundance of these small fish that even novice dolphins, with little hunting experience, have plenty of opportunity to fill their stomachs.

Such sardine bounty is a reminder of how prolific the world's oceans once were. Similar spectacles – involving other fish and other predators – would have been regular occurrences before centuries of intensive hunting and fishing by humans.[6] It is the inaccessibility of this stretch of South Africa's coastline, coupled with recent advances in managing the sardine fishery, which has kept this part of nature's largesse still bounteous.

The sardine resembles many other small, sleek, silvery shoaling fish. It is a successful evolutionary design. The herring-type design of members of the group Clupeomorpha dates back in the fossil record to the early Cretaceous, more than 120 million years ago.[7] Having a counter-shaded body, dark above and silvery on the

sides and underneath, offers camouflage no matter from which direction a predator approaches. The reflectiveness of the silvery scales tends to mirror – literally – the ambient light levels at that depth in the water. A lethal flaw is the silvery flash from a sardine's scales as it twists and turns, revealing itself to predators above.

Scales, as well as offering camouflage, form the fish's protective covering, which is coated in mucus. Unfortunately for sardines, scales and mucus are easily dislodged, exposing the body surface to infection by bacteria, fungi or parasites. If sardines are caught in fishing gear, and are returned to the water because they are too small to be caught legally, they usually die immediately or later from infection.[8]

Sardines, like other fish of the herring family, tend to form a school. Strictly, a school refers to fish of the same species while a shoal is a more general term, describing closely packed fish that may be of more than one species. Here, we will use school or shoal interchangeably. Fish biologists J.H.S. Blaxter and F.G.T. Holliday define a shoal as 'a group of fish which are polarized and orientated in the same direction as a reaction to one another . . . The fish tend to have a regular spacing and move at about the same speed.'[9]

Living in a shoal has survival value. For predators who target individual sardines, trying to pick out one fish against a twisting, shimmering wall of many thousands can be agonizingly difficult. Under attack, a sardine shoal forms into a shape-shifting ball. From the sardine's perspective, the larger the number of fish in the ball the better. The ball bulges, puckers and flows like a giant organism as it responds to individual attackers. Panicked fish no longer keep a uniform distance. They move faster and alternately bunch and scatter. As soon as any fish become separated from the main shoal they become much more vulnerable. Attackers pick them off.

There are other advantages to schooling. When freely swimming and not under attack, a sardine school morphs into geometric shapes – a disc, ellipsis, crescent or sphere. At night, when feeding, a school may be strung out in a long ribbon shape.[10] Being part of a school means that individual fish travel less far to scout the environment and so they consume less energy. Fish at the edges of the shoal do the scouting. These 'edgy' fish are also the first to notice approaching predators.

Shoaling fish save energy in another way. As a fish swims, its beating tail creates reduced pressure and swirling vortices in the water behind, and a following fish can benefit, rather like a racing car tucking closely behind the one in front, riding the slipstream.

Occasionally, living in a shoal is a disadvantage. That is when something so big – the mouth of a whale or a giant net – engulfs hundreds or thousands of fish at once.

How do sardines keep together in a shoal? By some combination of senses – sight, sound and detecting larger disturbances in the water – each sardine can perceive its neighbours and their position and movement, and makes checks and balances to steer a course and gauge the appropriate speed.

Is there a leader to the shoal? It seems not, because fish shift position, although some individuals may be more adventurous than others. There are counterbalancing effects that cause fish to change position in the shoal. Being on the outside puts a fish closer to a fresh food source but makes it more likely to be predated. Being on the inside keeps the fish away from predators, but also away from food. Fish densities in the middle of a school can be sufficient even to deplete oxygen levels – by a quarter in some cases – which can cause physiological stress.[11]

Other factors aside, the larger and more tightly coordinated a sardine school, the greater the probability that an individual within it will survive an attack. Repeated observations show that

this is the case, and computer modelling of virtual schools of fish supports this explanation.

For most predators, the trick in attacking a sardine school is to cause disarray so that the school panics and a smaller school breaks away from the main one. As we have seen, in South Africa's Sardine Run it is usually several common dolphins that do this job before other animals benefit from their expertise.

To better understand the working life of a sardine we need to shift our attention from our land-based, air-breathing existence and imagine life underwater. On land, we strongly experience the pull of gravity and we will collapse if we do not expend effort – consciously or unconsciously – in keeping ourselves upright. The airy medium we move through is thin and offers little resistance until we move through it quickly, as a runner or cyclist does.

In water we are buoyed up by the medium around us, which is eight hundred times denser than air. Most fish (with the conspicuous exception of sharks and their relatives) are neutrally buoyant – they neither sink nor rise should they stop swimming. They are effectively weightless. If we try and move through water as we do on land, we have to push the water aside. When we swim or dive we extend our body into a streamlined shape to minimize frictional drag. Fish already have that advantage. Typical elongate fish, such as sardines, are torpedo-shaped, technically called fusiform – rounded at the front and tapering to the rear. This body shape cuts through the water with minimal drag – some ten times less drag than a sphere or an ungainly human body.[12]

Streamlining, and the need to overcome friction, means that other things being equal, a bigger fish moves through the water more efficiently than a smaller one. In sailboat racing different classes of boat reflect the fact that bigger boats cut through the water and waves more efficiently than smaller ones, and move faster. Among fish of similar shape, a larger one generally swims

faster and consumes less energy per kilogram than a smaller one. Shape for shape and size for size, a large fish can outswim a smaller one. Tuna and sharks, and dolphins for that matter, are much larger than their sardine prey.

If we took into account shape and size considerations alone, the poor sardine would look to be in trouble. In theory a fast-moving predatory fish could track a school of sardine and simply pick off a meal whenever it needs to. Luckily, there are other factors at play. And surprisingly, the availability of oxygen is one of them.[13]

Fish, like most animals, need oxygen to fuel the chemical reactions, called respiration, that liberate energy to contract muscles and to power many of the body's other functions. Most fish gain the oxygen they need through their gills – feathery structures normally hidden beneath the body just behind the head. When fish breathe, they pass water across the gills, which are richly supplied with blood and absorb oxygen from the water while at the same time releasing waste carbon dioxide. This gas exchange happens across the gills' surface layer. This is highly folded (hence the gills' feathery appearance) to increase the surface area for gas exchange.

The concentration of oxygen in seawater near the ocean's surface where sardines live is normally more than thirty times less than in air.[14] Oxygen also moves (diffuses) much more slowly through water than through air. Absorbing oxygen into the body is a major limiting factor in the life of a fish, and for this factor a bigger body size is not better – it is more challenging.

Any fish that gains its oxygen supply across the gills will normally benefit from having a highly folded surface layer in the gills to absorb oxygen. At a miniature scale, the surface for absorbing oxygen is effectively two-dimensional (a layer), whereas the body's cells that the oxygen is supplying are three-dimensional objects – they have volume. As a fish becomes larger, the ratio between

surface area and volume changes. By way of explanation, imagine an oxygen-absorbing, cube-shaped creature with sides of 1 cm. Its volume is 1 cubic cm ($1 \times 1 \times 1$). It has six sides, so its surface area is 6 square cm ($6 \times 1$). The 1 cubic cm of its body can absorb oxygen from 6 square cm of surface. Now imagine the cube has grown to have sides of 2 cm. Its volume is now 8 cubic cm ($2 \times 2 \times 2$) while its surface area is 24 square cm ($6 \times 4$). Now each cubic centimetre of its body is supplied only by 3 square cm of surface. The so-called surface area to volume ratio has fallen from 6:1 to 3:1. Extrapolating to a fish, with its more complex shape, as it grows bigger it needs a more folded gill surface to get sufficient oxygen for its cells. But there are limits.

Although fast-swimming fish such as tuna have a highly efficient gas-exchange system, with enormously large gill surface

The bluefin tuna is a fast-swimming sardine predator. The Pacific bluefin tuna, *Thunnus orientalis*, grows to more than 3 m long and can weigh 550 kg. In Japanese fish markets, a single fish can command more than £500,000.

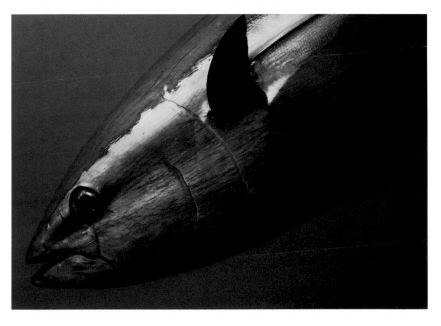

areas, they cannot swim for long periods at high speed – the speed needed to pick off sardines. They become exhausted and short of oxygen, and need to recover.[15] In any case, while they are attacking a small bait ball, the larger shoal slips away, and the tuna have to hunt them down another day.

Those senses that enable the sardine to swim in tightly packed schools shape their lives in other ways. The eyes of sardines are positioned at the side of the head, to give a wide field of vision, so they can see other fish in the shoal and locate predators. Their eyes are orientated slightly forwards too, so the field of view of the two eyes overlaps slightly, giving them stereoscopic vision and depth of field. If need be, sardines can focus on small plankton just ahead of them, picking them off one by one.

The specific light-sensitive cells in the eyes of sardines reveal that they have colour vision, although this is likely to be rather different to our own.[16] In clear seawater about 99 per cent of sunlight penetrating the surface is filtered out by a depth of 100 m. So, even in daytime, sardines are used to swimming in varying light levels, which change as the fish swims up or down. Not only this, but seawater rapidly filters out red wavelengths of light. Below about 10 m, anything red appears black or grey under ambient light. The colour balance changes with depth, becoming bluer.[17] Despite this, colour vision would be valuable to a sardine, enabling it to distinguish different kinds of prey and other features in its environment.

Sardines have ears, but they do not connect to the body surface as ours do. The ear of a sardine is roughly equivalent to the inner ear of a human, but less complex. Like a human inner ear, it contains a system of three semicircular, fluid-filled canals, orientated at right angles to one another. Depending on the orientation of the head, fluid shifts in the three canals, triggering movement of a chalky ear stone (otolith) associated with each canal, which

The eyes of sardines allow both forward and wide-angle vision, to focus on food items and spot predators.

34

is detected by sensory cells. This system enables the fish to orient relative to the pull of gravity. Even without visual cues, it can detect up and down and know how its body is positioned. Vibration within the fluid-filled system, and of the otoliths, is in part how a sardine detects sound.[18] Incidentally, scientists use otoliths for ageing fish. When sectioned, otoliths reveal a system of rings, rather like tree rings, with each ring associated with a year's growth. Fish scales too have annual growth rings. Scientists use them to age fish and work out how quickly fish in a population are growing. This gives insight into how fish are responding to fishing pressure.

Clupeid fish – herring, sardines and their relatives – have especially good hearing because the swim bladder extends forwards and connects to each ear. The air-filled swim bladder amplifies sounds through bony connections with the ear, and clupeid fish can detect soft, high-frequency sounds of up to 40,000 Hz, well beyond the range of human hearing. Such hearing acuity has survival value. Shad can hear the high-frequency cries of attacking dolphins and it is quite possible that sardines do too.[19] Herring have a party trick – at night they expel air from the anus, accompanied by a high frequency sound. These 'farts' – scientists mischievously call them FRTs (fast repetitive ticks) – probably help the fish locate one another at night.[20] Sardines too might have means of communication – whether by sight, sound, smell or vibration – that we have yet to discover.

Sardines, along with most other kinds of bony fish, probably have highly sensitive senses of smell and taste. Sardines have two nostrils but these are not connected to the throat, as in humans. Instead, each leads to a blind-ended sac lined with chemical-sensitive cells. As the sardine swims, water is circulated through each nostril, which detects smell. Sardines should be able to distinguish different water currents by the cocktail of chemicals

within them. They can probably track down food sources by the chemicals released by different kinds of plankton. And using smell, they might move away from chemically polluted water. When feeding, taste buds lining the mouth help register the nature of what the fish is eating. A sardine eating something with an unpleasant taste can expel it – coughing it out.

Sardines and most other fish have a sense that we do not. Along the sides of the body – although in clupeids, this tends to be restricted to the head – lies a system of pores that connect to fluid-filled canals. Together, they form the lateral line system, with the pores visible as dots on the body surface. Changes in water pressure are transmitted through the lateral line system and trigger sensory cells to relay information to the brain. This information concerns vibrations – rhythmical pressure changes in the surrounding water – whether audible or not. It also includes water movement, such as from a flowing current or the beat of a fish tail nearby. In darkness or light, this 'touch at a distance' gives sardines awareness of a three-dimensional world around them, detecting nearby members in the shoal or the approach of a predator.

Of course, most fish, and sardines among them, are rather adept at swimming. Like many fish, a sardine swims by bending its body into a slight S-shape, which moves backwards as a pulse, from head to tail. The bending action increases towards the tail, so that the biggest thrust comes from the tail pressing against the water. The muscle that powers the bending movement lies along the sardine's flanks. It is the sardine 'meat'. Look closely when eating a tinned or freshly cooked sardine and you will see that the muscle is divided into blocks, separated vertically from one another by a zigzag boundary. These interlocking muscle blocks, called myotomes, contract along one flank of the fish and relax on the other, causing the body to bend. Look even more

closely, and you will see that not all sardine meat is the same colour. Some is relatively pale, while some is dark. The pale muscle (biologists call it white muscle) comes strongly into play when the sardine is panicking and needs a burst of speed. The red muscle is for sustained swimming.[21]

A skeleton is needed to convert muscle contraction to body movement. Sardines, along with most other fish – more than 26,000 species – belong to a group called teleosts (Teleostei), the so-called 'modern' ray-finned fish.[22] Teleost fins are supported by bony spines called rays. Teleosts have hard, bony skeletons not dissimilar to our own. A skull (cranium) surrounds and protects the brain. The backbone (vertebral column) is an interconnected chain of bony structures not unlike the parts of a necklace, but with each element cushioned from the next by a pad of cartilage. The backbone surrounds and protects the delicate spinal cord that runs from the brain and then branches into nerves that connect to most parts of the body.

The backbone's resilience to compression, coupled with its flexibility, provides the ideal rod against which muscles can contract to flex the body. Bony extensions from the backbone act as levers and anchor the surrounding muscle, while ribs provide support and protection for vital organs in the abdominal cavity. A sardine to be canned for eating normally has its head, guts and fins removed during processing. Pressure-cooking then softens all the bones so you barely notice them. All, that is, except the backbone, which remains as a crunchy strand.

A key difference between humans and fish is in the arrangement of bones supporting the appendages used for locomotion – in humans, arms and legs; in fish, of course, fins. The fins are the exquisite control surfaces that direct the sardine's speed and direction. Each fin has a system of bones anchoring it to the body and connecting it to other parts of the skeleton. The fins are

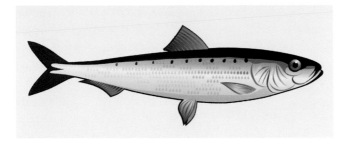

Fins give the sardine its high manoeuvrability.

flexible, supported by rays, and with the conspicuous exception of the tail (caudal) fin can be retracted or extended at will. Rather like a pilot controlling the flaps and ailerons on an aircraft's wings, a sardine achieves fine control by adjusting its fins.

All swimming movements are aided by the sardine being more or less neutrally buoyant. If it were to stop swimming momentarily, it would neither rise nor sink. It achieves this by having a swim bladder – an air-filled sac – that evolved from an outgrowth of the gut. A remarkable system of blood vessels, called the *rete mirabile* – Latin for 'marvellous net' – works as a counter-current system, concentrating gases inside the sac. The space filled with gas counteracts the fish's tendency to sink. If the swim bladder were punctured, the fish would be denser than the surrounding water and sink. By fine control of the amount of gas in the swim bladder, the fish can adjust its trim so it is neutrally buoyant. This saves it a great deal of energy, because it does not need to swim to maintain its level in the water.

The evolutionary co-relationship between predator and prey is sometimes likened to an arms race.[23] Over generations, as the sardine evolves – through sharpening of its senses, swimming power and behaviour – it becomes better at avoiding its predators, so predators must evolve compensatory responses if they are to keep pace. Reality, in fact, is more complex. Predators have

other fish to feed on, not just sardines, and various environmental factors can keep sardines temporarily apart from their predators. Predators have other concerns, including trying to reproduce and avoiding their own predators. Nevertheless, the survival of both sardines and their predators over many thousands of generations suggests that they are still locked in a struggle, and there is no sign of it abating.

The sardine may be a humble fish, quite small in the panoply of fish roaming the oceans, but it is a successful one. Its sensory apparatus, its swimming ability and its behaviour have enabled it to survive in various incarnations for more than 20 million years,[24] outmanoeuvring its predators and living to feast and procreate another day.

Humans are the most pervasive sardine hunters of all. But before a sardine can grow to the size where it is of interest as human food, it must run the gauntlet of an astonishing assemblage of smaller predators. As we shall see in the next chapter, fewer than one sardine in 10,000 survives the odyssey.

## 2  A Quicksilver Fish in a Strange World

It takes a certain brand of rugged determination to closely examine 12,000 sardines over a 41-month period. Between 1935 and 1938, leading British marine biologist Charles Hickling and his colleagues at the UK Ministry of Agriculture and Fisheries did just that.[1] They weighed and measured European sardines, and dissected many to examine the state of the gonads and so determine the sardine's spawning season. They chemically analysed sardine flesh to assess its dietary value and squeezed stomach contents onto blotting paper to work out the average weight of food in the sardine's stomach at different seasons. Unsurprisingly, they discovered that sardines do most of their feeding from spring through to autumn. Hickling also took some stomach samples and stirred them into water, withdrawing a few drops with a pipette and examining them under the microscope. He was one of several early twentieth-century marine biologists, many of them French, willing to probe their way through the gut contents of sardines. What they discovered is that to understand the life of the sardine you need to appreciate the lives of some of the smallest organisms in the ocean – the creatures on which sardines feed.

These tiny organisms are part of a vast community that drifts in the ocean's surface waters. Called plankton, from the Greek *planktos* for 'drifting', many can propel themselves, but only weakly, so they cannot outpace a moderate current. Most are

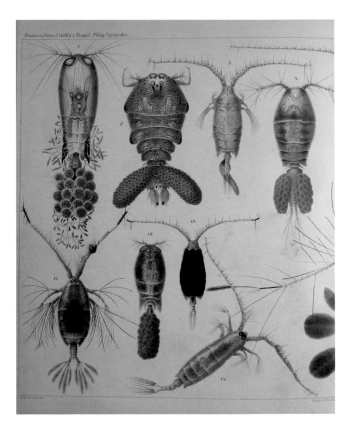

microscopic or barely visible to the human eye. The largest include krill and jellyfish. The plankton community is divided into the plant forms, phytoplankton, and animal forms, the zooplankton, although there are a few – certain kinds of microscopic dinoflagellate – that have features of both.

The ocean's plankton community is the world's largest assemblage of plants and animals, and the most underrated. Plant plankton trap a similar amount of carbon and liberate a similar

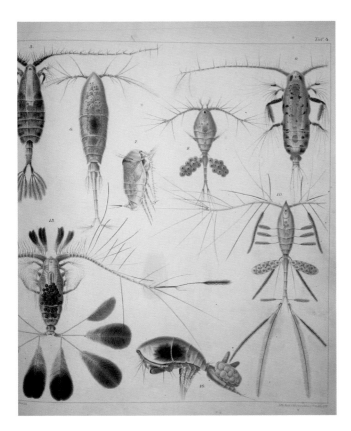

A plate from Wilhelm Giesbrecht's *Fauna und Flora des Golfes von Neapel und der Angrenzenden Meeres-Abschnitte* (1892), showing a selection of copepods from the Mediterranean Sea.

volume of oxygen compared to all the trees and grasses on land. Billions of tonnes of shrimp-like zooplankton called copepods – a favourite food of sardines – rise and fall several hundred metres in the ocean every 24 hours. This is a daily journey equivalent to us climbing and descending a small mountain. This vertical movement is the planet's largest animal migration.

Copepods are sometimes dubbed, rather inaccurately, the 'insects' of the ocean. Resembling miniature shrimp, and only

1 to 5 mm long, they outnumber all the insects on land. Their abundance becomes less surprising when we consider that the oceans cover nearly 71 per cent of Earth's surface, with the average (mean) depth of seawater being 3.7 km. The oceans – being a much more three-dimensional environment than the land – provide more than 99 per cent of Earth's living space.[2] Sardines live and die in the top 200 m of this space, in specific places.

As plankton expert Willie Wilson puts it, 'Phytoplankton are the powerhouses of the open ocean.'[3] As they float in the ocean's surface waters they trap sunlight and convert simple chemicals into more complex ones through photosynthesis. This is the same process that plants on land use to convert water and carbon dioxide, using solar energy, to make organic (carbon-rich) substances. These chemicals – including carbohydrates, proteins and fats – are the building blocks of living organisms.

If we are interested in sardines we should be interested in phytoplankton. The phytoplankton, one way or another, are implicated in everything the sardine eats. When young, sardines feed directly on phytoplankton. When older, they consume phytoplankton or zooplankton. The latter will have eaten phytoplankton or other creatures that have eaten phytoplankton. To find out where sardines might be thriving, look for dense patches – blooms – of phytoplankton. Typically, they colour the water green and can be seen from near space by remote-sensing satellites.[4] Where phytoplankton are plentiful, so too will be the zooplankton that feed on them, and in turn so will larger creatures, including fish.

At certain times of year, diatoms – a type of phytoplankton – can be the sardine's staple food. The largest are just visible to the eye and they come in an assortment of shapes, but all are based on a 'pillbox' structure, with closely fitting top and bottom 'lids' made of silicon dioxide, the major constituent in glass. So abundant are diatoms that in upwelling regions where their

In the ocean as seen from a remote-sensing satellite, swirls of green (showing chlorophyll) indicate phytoplankton blooms.

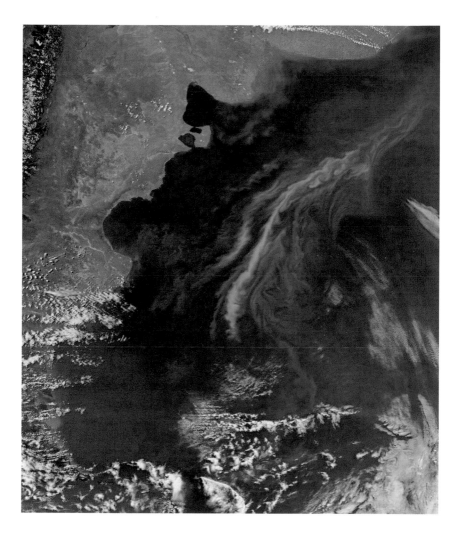

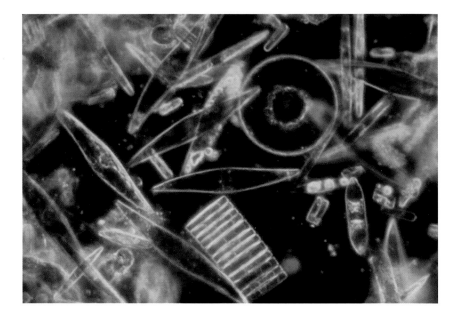

Tiny diatoms such as these are the food of larval sardines and sometimes adults.

skeletal remains have sunk to the sea floor, millennium after millennium, they create a muddy sediment called diatomaceous ooze that can reach hundreds of metres thick. The success or failure of a sardine population hinges on the plankton it eats – and no more so than on the copepods it eats. These tiny crustaceans superficially resemble shrimp and to a sardine are highly nutritious. Like other crustaceans, copepods have an armoured outer skeleton (exoskeleton) and a body divided into segments, plus numerous jointed limbs. Moving their limbs and sweeping their two long antennae, most copepods swim with a jerky swim and then sink motion. They feed on phytoplankton, smaller zooplankton, tiny floating eggs and waste particles. Copepods can graze selectively, capturing individual prey items, or en masse by straining the water through filtering combs on

their limbs. As adults, copepods will consume sardine eggs and sardine larvae; so too will the planktonic larvae of crabs, shrimp and lobsters. But as sardines grow older, the tables are turned.

In Hickling's classic study of Cornish sardine stomach contents, he found three types of copepod to be the European sardine's favourite food, along with the tiny young of decapod crustaceans such as crabs, shrimp and lobsters.[5] At times, sardines are selective feeders, in that they can pick out certain kinds of plankton from others, while at other times they swim with their mouths open, filtering diatoms by the hundred from the water. As sardines grow and mature, they dine on plankton of increasing size. In turn the members of the plankton community that eat them are larger. Among the largest are jellyfish, comb jellies and arrow worms.

For a young sardine, most jellyfish carry lethal toxin. Brushing against a jellyfish's tentacles, the fish rapidly becomes immobilized by hundreds of stinging darts. The tentacles then shorten and

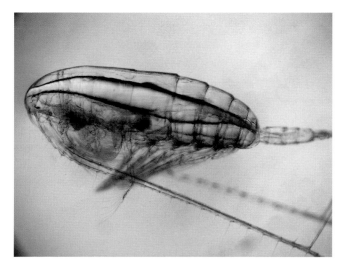

This species of copepod, *Calanus finmarchicus*, at less than 5 mm long, is a common food for sardines in the northeast Atlantic.

bend, drawing the young sardine inexorably towards the stomach where – whether it is dead or still living – it is gradually digested.

In the 1960s the sardine and anchovy fishery off Namibia was the most productive fishery in the world. At its peak in 1968, vessels from more than ten nations harvested about 1.4 million tonnes of sardines in a single season.[6] From the early 1990s, these surface waters became a sea of jellyfish – mainly European sea nettles, *Chrysaora hysoscella*, and the crystal jelly, *Aequorea aequorea*. Comparatively few sardines and anchovies exist in these waters now, and until recently they had to navigate a veritable forest of tentacles. The jellyfish were once so dominant that they burst fishing nets and blocked the inlet pipes of power stations.[7]

Comb jellies, or ctenophores (meaning 'bearing combs'), are transparent and look superficially like jellyfish, but most are plum- or walnut-shaped. They have eight rows of tiny hair-like structures, cilia, along their sides, which under the microscope look like the teeth of combs. The beating of the cilia slowly propels the animal, generating rainbow-colour shifts in refracted light. Comb jellies range from a few millimetres long to more than

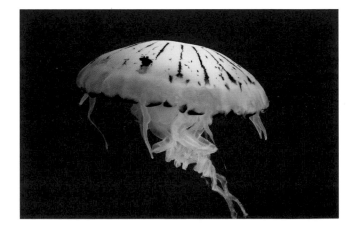

Jellyfish, such as this purple-striped jelly, *Chrysaora colorata*, are common predators of younger sardines.

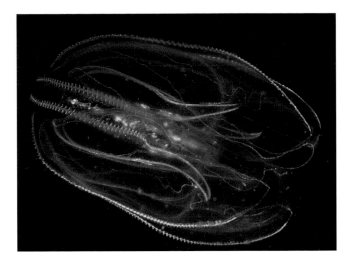

*Mnemiopsis leidyi,* the comb jelly that devastated the Black Sea sardine and anchovy fisheries in the 1980s and 1990s.

15 cm, and like jellyfish are voracious and have a large stomach. Unlike jellyfish, they lack stinging cells and their tentacles are sticky rather than venomous. One of the world's most momentous fishery collapses occurred in the Black Sea – an offshoot of the Mediterranean – in the 1980s, the fishery's demise attributed to a comb jelly called *Mnemiopsis leidyi*.

The Black Sea is a strange body of water. The geology of its surroundings, the chemical composition of water running into it and the shape of its basin ensure that for much of its depth it is anoxic (without oxygen). Only in the near-surface waters is life abundant and biodiverse. Sometime in the late 1970s or early 1980s, *Mnemiopsis* arrived. Adults are about the size of a hen's egg, and they or their larvae were probably carried in and released from the ballast tanks of ships arriving from the Gulf of Mexico and the northeastern United States. The population of *Mnemiopsis* rocketed, progressively removing copepods, fish eggs and then anchovy and sardine larvae.[8]

Several factors probably accounted for the comb jelly's success and the fishery's failure. *Mnemiopsis* was introduced to a region where no marine organisms had experienced it before, and predators, parasites and other controlling factors had not evolved locally to keep its numbers in check. A shift in climate caused numbers of zooplankton to decline temporarily, and with them, the fish such as anchovies and sardines that fed on them. In any case, overfishing had already dramatically reduced fish numbers. So, the stage was set for *Mnemiopsis* to harvest the zooplankton with little competition from other predators. By 1993 *Mnemiopsis* was estimated to form as much as 95 per cent of the animal biomass in parts of the Black Sea, with sardines and anchovies only making up a tiny fraction of the remaining 5 per cent. At the swarm's peak, one cubic metre of seawater contained more than three hundred individuals.[9] That density is equivalent to having more than one hundred egg-sized comb jellies swimming around in your bathtub.

Another nemesis of the young sardine are arrow worms, also called chaetognaths ('bristle jaws'). Shaped like an arrow with fins resembling flight feathers, they range in length from a few millimetres to several centimetres. They lack eyes but use sensory cilia to detect vibrations and water movement that betray the presence of young sardines. Once located, the arrow worm darts forwards and impales the luckless victim using gruesome mouthparts that grab or stab.

Sardines spawn in the summer and over a prolonged season. Some shoals spawn sooner than others. Exact spawning locations vary from year to year, as does the depth in the water, anywhere between about 10 m and 70 m depending on species. Scientists use fine-meshed nets to gather sardine eggs from the water and so work out – from the number of eggs in a given volume of seawater – where the peak of the spawning took place. By calculating how

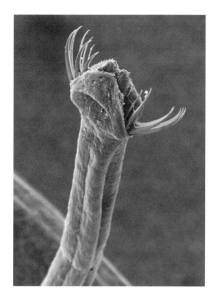

The head of an arrow worm (Chaetognatha). Arrow worms, at less than 2 cm long, are one of the most voracious predators of larval sardines.

many sardine eggs are in a geographic region, they can estimate how many spawning females produced them and calculate backwards to the entire number and weight of sardines in the area. This is one way of working out the fish stock that is available to be fished.[10]

In one season, a mature female European sardine releases some 60,000–80,000 eggs into the water, which are fertilized by one or more males releasing his sperm (milt) alongside her. The attrition rate for these eggs, the larvae into which they hatch and the juvenile sardines they grow into is high – fewer than one in 10,000 is likely to survive to adulthood and breed.

Depending on water temperature – eggs develop faster in warmer water – the eggs of the European sardine hatch in three to four days. The young larva that emerges is less than 4 mm long, looking like a miniature tadpole, with a bulging yolk sac – its

Stages in the development of a young Pacific sardine off California, from a newly hatched larva with yolk sac to a several-week-old juvenile sardine that is able to start filter feeding.

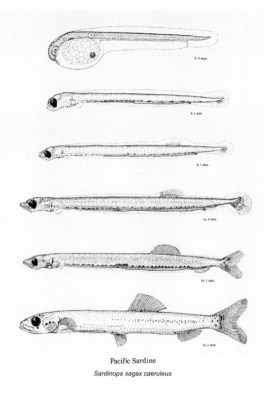

Pacific Sardine
*Sardinops sagax caeruleus*

temporary food source – extending beneath and behind the head. By about twelve days old, the 6-mm-long larva has consumed the yolk sac and the mouth, eyes, gills and fins have developed. It is recognizably a miniature fish. It can now feed for itself, consuming smaller plankton, including juvenile copepods, copepod eggs and diatoms, by picking them out of the water one by one.[11]

At the size scale of a larval sardine, the water around it has the consistency of syrup. Swimming through it is so arduous that it has to rest every few seconds. It eats by targeting a juicy morsel

– a copepod larva perhaps – bending its body into an S shape, opening its mouth and then straightening and darting forwards. With luck and a fair degree of skill, the morsel enters the mouth. As the larva grows, it finds it easier to overcome the viscosity of water and attacks prey more often and more successfully.

A sardine larva can survive only a few days without food. If it starves, there comes a point when it is alive but too weak to feed – the 'point of no return' (PNR).[12] Fisheries biologists are interested in the state of larval sardines because it tells them how successful the year class (the number of fish entering the fishery) is likely to be the following year. These scientists catch larvae and then use factors such as body dimensions and fat content to work out how healthy they are. For larvae to survive, food needs to be of the right size (diatoms, copepod eggs or young copepod larvae), nearby and plentiful. Such conditions vary from year to year. Off California, marine biologist Reuben Lasker suggested that for anchovies (and later others suggested for sardines) good years for larvae were associated with calm weather.[13] In the absence of spring and summer storms, patches of the right sort of phytoplankton and zooplankton remain for weeks on end, and the sardines can find them and spawn nearby. The eggs then develop and hatch in the vicinity and the larvae have a good chance of finding enough zooplankton food. Like most other planktonic organisms, sardine larvae can rise or fall in the water to intercept patches of food at the right level. There are other factors at play – the abundance of predators, for example – but availability of suitable food is key.

At about 4 cm long, a young sardine resembles an adult but without scales. It has grown structures called gill rakers, which are extensions of the bones that support the gills. On the rakers' surface are outgrowths called denticles, rather like the teeth of a comb. The gill rakers and their denticles form an array that filters

the water that enters the mouth and exits over the gills. The fish can now filter feed, swimming with the mouth open and straining the water for food items, trapping them on the gill rakers and swallowing them. The sardine now has the choice of either picking out individuals or filter feeding – of being selective or less discriminating. This flexibility allows juvenile and adult sardines to be opportunistic, to change their feeding method depending on the food items present. Smaller, more abundant items such as diatoms, copepod larvae and small adult copepods can be filtered from the water, while larger copepods are picked out singly.[14]

Young sardines grow surprisingly quickly but their growth slows when they reach adulthood. The Pacific sardine off California, which grows slightly faster and larger than its European cousin, reaches as long as 19 cm ($7\frac{1}{2}$ in.) by the end of the first year, 23 cm (9 in.) by the second and about 25 cm (10 in.) by the third. The few fish lucky enough to survive for more than ten years are rarely more than 30 cm (12 in.) long. By the time sardines are a year old they are worthwhile prey for a slew of large predators, including fish, diving birds and aquatic mammals, and, most voracious of all, humans.

In the early 1920s, when the British marine biologist Sir Alister Hardy was travelling across the North Atlantic, sampling plankton with towed nets, he became acutely aware how patchy the blooms of phytoplankton and swarms of zooplankton are in the open ocean. Take a net sample one day in a particular spot at a particular depth, and it can be teeming with microscopic animals and plants. The next day, the net can be almost bare.

One of Hardy's interests was the health of the UK's herring fishing industry (which was then much bigger than it is now). Herring are larger than sardines but, like their smaller brethren, feed on small plankton. Hardy was well aware that herring abundance and growth depended on the supply of plankton, and so

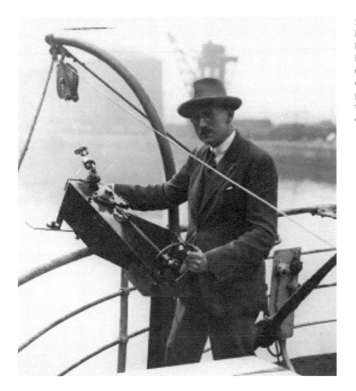

Sir Alister Hardy with his Continuous Plankton Recorder (CPR). The device samples plankton when towed behind a commercial ship.

measuring this supply should allow scientists to estimate the likely success of the herring population.[15] His thoughts ran along the lines, 'How can one gain a better sense of the composition and abundance of plankton, rather than at intervals of time or space simply dipping a net into the ocean's vast expanse?' In any case, sending even a small scientific sampling boat out to sea is expensive – tens of thousands of u.s. dollars a day at today's rates. Hardy's ingenious response was to construct and design a device that could be towed behind a commercial vessel and would take a plankton sample continuously.

About 1 m long, originally made of gunmetal and other corrosion-resistant metals, and entirely mechanical, Hardy's Continuous Plankton Recorder (CPR) was first deployed on commercial shipping in 1931. The device is supremely robust, withstanding surging seas under gale-force conditions. It is towed at a depth of about 10 m for up to 500 nautical miles (925 km) before its internal cassette mechanism is brought back on board and exchanged to allow further sampling. For each cassette, an ingenious system of propeller-driven rollers draws a silk mesh strip slowly across a sampling aperture, sandwiches the collected sample between another silk sheet, and plunges the sample into a tank of preservative formalin.[16]

Back at base – the headquarters of the Sir Alister Hardy Foundation for Ocean Science (SAHFOS) in Plymouth, England – the CPR tank of preservative is opened and scientists first assess the greenness of the silk (a guide to phytoplankton abundance) and then cut the silk into sections representing 10 nautical miles of towing. Plankton specialists then painstakingly view samples of the silk under the microscope to identify and count the constituent plant and animal plankton. This diligent work, over several decades, has yielded invaluable data about how the composition of plankton in the North Atlantic has changed, and is changing.

Today there are about 75 of Hardy's CPRs deployed across the world – in the North Atlantic, North Pacific and the Southern Ocean. The UK CPR programme has also spawned daughter projects, in South Africa, Japan, Australia and New Zealand. Since 1994 electronic instrumentation has been added to CPR recorders, to measure environmental factors such as sampling depth, temperature and conductivity (a measure of salinity), as well as taking water samples for later analysis. The CPR programme has taken tens of thousands of continuous samples over the last 85 years – the most extensive plankton-sampling programme in the world.[17]

Nowadays, the 85-year time series has taken on special relevance, given widespread concern over climate change and other factors affecting the oceans. Changes in the distribution and abundance of plankton are indicators of widespread environmental change. For example, CPR surveys have revealed a decline in clupeid larval abundance in the European North Atlantic in the years 1986–2006 compared to 1948–85.[18] CPR studies show temperature-sensitive shifts in the community of organisms in the surface waters of the northeast Atlantic over several decades, which can also be related to the abundance of sardine eggs in the English Channel.[19] Since the early 1980s, the relative abundance of different copepod species in the English Channel has shifted, along with other indicators of a swing from a colder regime to a warmer one. The cooler-water copepod *Calanus finmarchicus* has largely been replaced by the warmer-water *Calanus helgolandicus*.[20] This has implications for the sardine. If the reproduction and seasonal abundance of copepods were to become out of phase with the spawning and growth cycle of sardines, then the number of young sardines joining the fishery could be dramatically affected.

Some 9,000 km from Plymouth is a formidable sampling programme today operated by three scientific partner organizations

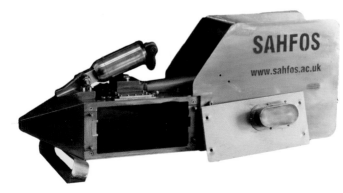

A modern Hardy's Continuous Plankton Recorder (CPR). Such devices have been used to sample the sardine's planktonic food in the northeast Atlantic, providing an unrivalled record for more than 85 years.

on the u.s. Pacific coast (the Department of Fish & Wildlife, the NOAA Fisheries Service and the Scripps Institution of Oceanography). While it cannot compete with the Hardy CPR programme in its geographical reach, it makes up for that in its intensity – a sampling programme that combines a range of oceanic physical and chemical measurements, as well as plankton sampling, along a grid system that extends some 300 km offshore. At its peak in the 1950s the California Cooperative Oceanic Fisheries Investigations (CalCOFI) stretched from southern Canada to the tip of Baja California, Mexico.[21] Today the programme runs the 1,000 km from San Francisco to San Diego, with vessel cruises four times a year.[22]

If Hardy's CPR was prompted by concern for UK herring stocks in the 1920s, the CalCOFI programme began as a response to the u.s. sardine crisis of the 1940s. In the 1947–8 season California's entire sardine catch was 118,000 tonnes. A decade earlier, the catch had been six times this weight. The massive drop was putting the

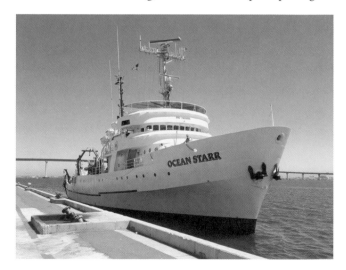

CalCOFI Research Vessel *Ocean Starr*. This vessel regularly undertakes sampling voyages for CalCOFI scientific investigations, deploying nets and devices that measure the sea's physical and chemical characteristics.

livelihoods of thousands of fishermen and fish handlers at risk. In 1947 the California legislature levied a landing tax on commercially caught sardines, with the money going to research to help identify the reasons behind the sardine decline. In 1948–9 the Marine Research Committee (MRC) – with members from five stakeholder organizations – oversaw two-ship and then three-ship sampling cruises. This programme was, by 1953, to be dubbed CALCOFI. The programme's data – and particularly the sampling of zooplankton, including fish eggs and fish larvae – inform the management of commercial fisheries, including that of the sardine.[23]

Among CALCOFI's achievements is recognizing that the community of organisms in the surface waters of the North Pacific, as European scientists have found in the northeast Atlantic, undergo dramatic shifts over timescales of several decades. These shifts impact on the sardine population as much as any other surface-dwelling fish. Another success was the programme promoting the ecosystem approach to fisheries research – accepting that wider physical, chemical and biological factors need to be taken into account when assessing the status of a fishery. And as to what prompted the creation of the CALCOFI programme in the first place – the collapse of the sardine fishery? A climate-induced shift in the oceanic plant and animal community was responsible, made worse by overfishing.[24] As we shall see later, these two factors, in combination, have become a common trigger for the collapse of sardine fisheries.

# 3  Fortunes Won

Scattered across the English city of Oxford in more than a dozen buildings – some medieval, some modern, some betwixt and between – is housed the Bodleian Library. The oldest part – still in use, with chained, leather-bound texts on shelves from floor to ceiling – dates back to the fifteenth century. The Bodleian is one of the world's truly great libraries and the second largest in the United Kingdom.

Affectionately called the 'Bod' by generations of Oxford University students and scholars, the library receives some 1,500 books a week and houses more than 12 million print items. In 1905 the English politician Augustine Birrell, later to become the Chief Secretary for Ireland, called it 'a great and glorious institution, one of England's sacred places'.[1] In earlier times its religious significance was almost its undoing. Without the humble pilchard, the Bodleian might never have survived.

The Bodleian Library can be traced back to a single room in about 1320. Founded with funds from Thomas de Cobham, Bishop of Worcester, the original library moved to larger premises in 1488, prompted by the donation by Humfrey, Duke of Gloucester, of more than 280 manuscripts. The duke's library survived for barely sixty years before it was denuded of much its contents by a visit from Richard Cox, Dean of Christ Church. Acting on legislation passed by King Edward vi, he arranged for the removal

A huer looking out for pilchard shoals. St Ives, Cornwall, c. 1905.

of any 'superstitious books and images' that could be interpreted as representing Roman Catholicism. So depleted, the library fell into disuse until the intervention of Thomas Bodley.[2]

Bodley had a distinguished academic career at Oxford before becoming a diplomat for Queen Elizabeth I and then a British Member of Parliament. He gained his fortune when he married wealthy widow Ann Ball in 1586. Ann, in turn, had inherited a thriving business from her husband, Nicholas Ball, a successful pilchard merchant. On marrying Ann, Bodley took over the controlling interest in the pilchard business, managing it to provide a steady and considerable income.[3]

On retiring from public life, Bodley focused on reviving Oxford University's ailing library, injecting funds and garnering initial donations of some 2,500 books. He shaped the library's refurbishment until its reopening in 1602 – the year of his knighthood. In the next decade he oversaw the library's expansion and its intention to become the world's first deposit library – aiming but falling short in keeping a copy of every book published in England. Tellingly, in his sixteen-page autobiography, *The Life of*

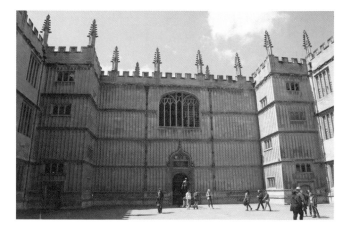

The entrance to the oldest part of Oxford University's Bodleian Library.

*Sir Thomas Bodley*, he makes no mention of his wife or the source of his fishy fortune.[4]

The pilchards that were the financial benefactors of the Bodleian came from coastal waters around Devon and Cornwall. Today England's rugged southwest peninsula is a tourist magnet. Quaint ports nestle in its peaceful estuaries or at the base of vertiginous cliffs. The peninsula's interior has always been granite-strewn and soil-poor. Until overtaken by tourism in the twentieth century, two industries have been the mainstay of Cornwall's economy – mining and fishing. Mining has dwindled to almost cottage-industry status. The fishing industry continues, but far fewer people are involved.

Sir Thomas Bodley (1545–1613), an English diplomat and scholar, founded Oxford University's Bodleian Library in 1602; he did so using the proceeds from pilchard trading.

The beginnings of the Cornish and Devon pilchard industry are lost in time. According to the Cornish industry's chronicler Cyril Noall it dates back to at least the middle of the thirteenth century.[5] Fishing for schools of Cornish pilchards requires coordinated organization and capital investment. By the sixteenth century there were two approaches. One was using a wall of netting into which the fish swam and entangled themselves. Traditionally, these drift nets were set in shallow water at right angles to the tidal current. The other method was by seine net, by which two or more boats paid out a net that encircled a pilchard school in shallow water.

The pilchard or sardine of British waters is *Sardina pilchardus*. Around Devon and Cornwall pilchards spend their entire lives on the continental shelf, but descend to near the bottom for much of the winter, when food is scarce and they lose much of their condition and oil content. They are caught in the greatest numbers between July and December, when they rise near the surface to feed on plankton and become plump and well-conditioned.

Pilchards became so important to the Cornish economy because they were abundant and easy to catch, and because

there was a ready market for them. Richard Carew, Member of Parliament and a local historian, after reviewing Cornwall's other sea fisheries in his *Survey of Cornwall* (1602), leaves the smallest but economically most important fish to last: 'But the least fish in bignes, greatest for gaine, and most in number, is the Pilcherd.'[6]

Salted pilchards were something of a delicacy in the Catholic countries of Italy and Spain where, mixed with rice or pasta, they became a familiar food during Lent and on Fridays, when meat had to be avoided. Other than locally in Cornwall and Devon, pilchards – whether fresh or salted – held little interest as a food in the rest of England.

Daniel Defoe, famed as author of the novels *Robinson Crusoe* and *Moll Flanders*, but in his day a prolific political pamphleteer, walked the length and breadth of mainland Britain and published his observations in the three-volume *Tour Through the Whole Island of Great Britain* (1724–7). On boarding a small boat in Dartmouth harbour, Devon, Defoe captures the quicksilver spirit of the pilchard, and attempts to catch them:

> I observ'd some small fish to skip, and play upon the surface of the water, upon which I ask'd my friend what fish they were; immediately one of the rowers or seamen starts up in the boat, and throwing his arms abroad, as if he had been betwitch'd, cryes out as loud as he could baul, 'a scool, a scool.' The word was taken to the shore as hastily as it would have been on land if he had cry'd fire; and by that time we reach'd the keys, the town was all in a kind of an uproar.
>
> The matter was, that a great shoal, or as they call it a *scool* of pilchards came swimming with the tide of flood directly, out of the sea into the harbour. My friend whose

boat we were in, told me this was a surprize which he would have been very glad of, if he could but have had a days or two's warning, for he might have taken 200 tun of them, and the like was the case of other merchants in town; for in short, no body was ready for them, except a small fishing boat, or two; one of which went out into the middle of the harbour, and at two or three hawls, took about forty thousand of them.[7]

Elsewhere, in parts of Devon and Cornwall, communities were better prepared for the arrival of pilchard shoals. In west

A huer's house overlooking the bay in St Ives, Cornwall. This is a substantial property for a worker in the fishing industry in the 19th century.

A huer signalling
the presence of
a pilchard shoal
while crowds
gather. St Ives,
Cornwall, c. 1905.

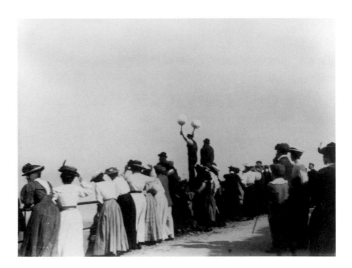

A huer signalling the presence of a pilchard shoal while crowds gather. St Ives, Cornwall, c. 1905.

Cornwall between the sixteenth and early twentieth centuries, local experts were paid big money to be fish spotters. By the nineteenth century they were called huers – probably from the old French verb *huer*, meaning 'to call out'. Each small fishing port had at least two, and the largest pilchard port, St Ives, had several. In the pilchard season, a huer would stand on a rocky promontory above the sea – for three daylight hours at a time for up to six days a week – scanning the water for fish. On finding them, his actions would set in motion a series of events that could galvanize the local community for days. The following description is based on mid-nineteenth-century accounts.[8]

The huer's tools of the trade were his keen eyesight, his sharp brain, his loud voice and his facility in directing proceedings using arm movements. After he shouted 'Hevva' (loosely translated as 'Here they are!'), the local community would be spurred into action. Armed with a custom-made signalling paddle, the huer indicated the direction and distance of the pilchard shoal.

Men tumbled out of houses and rushed to the shore, launching the main seine boat and a smaller auxiliary boat to assist in paying out the net. The huer directed the movements of the boats' crews as onlookers held their breath.

The pilchards had to enter water shallow enough so that the encircling seine net could form a wall from surface to sea bottom, so shutting off the fishes' escape. When the shoal reached this depth, the net was 'shot' (cast) and paid out around the seaward edge of the shoal, driving the fish towards the shore. As the shoal flexed and turned, the crews had to be adept at manoeuvring the boats and paying out the net to stop the fish escaping. Once the fish were enclosed and driven successfully towards the shore, with the net secured by several ropes, a roar of approval would go up from the onlookers ashore. Novelist Wilkie Collins, author of *The Woman in White*, in his travel guide *Rambles Beyond Railways* (1851) captures the atmosphere when the fish are about to be removed from the net:

Now, the scene on shore and sea rises to a prodigious pitch of excitement. The merchants, to whom the boats and nets belong, and by whom the men are employed, join the huer on the cliff; all their friends follow them; boys shout, dogs bark madly; every little boat in the place puts off, crammed with idle spectators; old men and women hobble down to the beach to wait for the news. The noise, the bustle, and the agitation, increase every moment.[9]

With some local variation, the large seine boats were about 10 m long and about 3.5 m across. Usually flat-bottomed so they could be dragged swiftly across a sandy shore, they carried no sails but the larger boats were propelled by six or eight oarsmen under the command of a steersman. The seine net itself, at about 160

fathoms (290 m) long and 8 fathoms (15 m) deep with long ropes attached, was of considerable weight. A second, shorter net might be used to close off the opening of the net at the shoreward side. At St Ives, two boats – one large, one smaller – shot the nets, while one or two other small boats helped in towing the net to shore. One contained the master seiner, also known as the lurker, who oversaw proceedings. It was twenty to thirty men on shore, called blowsers, pulling on one of two ropes, who finally pulled the net close to the shore.

This was just the first step of the process. That day, or occasionally a few days' hence, the fish were taken out of the seine and transported to shore. This usually involved a second net – called a 'tuck' – which was paid out by a smaller boat rowing around the inside of the seine net to constrain the fish further. Crews in other boats beat the water with oars and stones tied to ropes to scare the fish into the middle of the tuck. Once enclosed in the smaller net, the fish were hauled to the surface.

At this point, several boats would be centred on the thrashing cauldron of panicked fish boiling at the surface. Men would lean over the side of their vessels, each plunging a large basket into the writhing, silvery mass, and then emptying the contents straight onto the boat's floor. They repeated this action until they were knee deep in fish and the boat dangerously close to its limit, with water lapping close to the gunwales. Then they rowed to shore, where they were met with men with large wooden shovels who scooped the fish into hand-barrows, pushed by others who appeared on cue. As Wilkie Collins recounts:

As the filled barrows are going into the salting-house, we observe a little urchin running by the side of them, and hitting their edges with a long cane, in a constant succession of smart strokes, until they are fairly carried through the

Raising the tuck net to enable the pilchards to be dipped out of the net and into boats. St Ives, Cornwall, c. 1905.

Transferring pilchards from the tuck net to boats for landing. St Ives, Cornwall, c. 1905.

gate, when he quickly returns to perform the same office for the next series that arrive. The object of this apparently unaccountable proceeding is soon practically illustrated by a group of children, hovering about the entrance of the salting-house, who every now and then dash resolutely up to the barrows, and endeavour to seize on as many fish as they can take away at one snatch. It is understood to be their privilege to keep as many pilchards as they can get in this way by their dexterity, in spite of a liberal allowance of strokes aimed at their hands; and their adroitness richly deserves its reward.[10]

The fish-laden barrows were wheeled to dozens of waiting women and girls in a rectangular building, the salting house. The larger ones in the east of Cornwall were sometimes called, ironically, pilchard palaces. Inside, the barrow men emptied the pilchards onto the floor. Women filled buckets and provided each stacker with a bucket of fish and another of salt, layering the fish and salt in a gathering mound. Ultimately, this would form a rectangular pile some 1 m (3 ft) high, 1.2 m (4 ft) wide and 6 m (20 ft) long.

Once neatly stacked, and the floor swept, the fish would remain 'in bulk' in their stacks for five to six weeks. Oil, salt and water oozed from the fish and was directed by channels in the stone floor to a central well. Once the oil was separated and clarified, it became train oil, a vital lubricant used to keep the wheels of Victorian industry turning. The dregs – brine and blood – were sold to farmers as manure to fertilize Cornwall's comparatively barren land.

The pilchards, now taken out of 'bulk', were washed in clean salt water and packed in hogshead barrels, heading for Penzance harbour to be exported to Italy and Spain. To be classed as

The last of the pilchards are transferred from landed boats by horse and cart. St Ives, Cornwall, c. 1905.

In white aprons are the cellar maidens who salt the pilchards. St Ives, Cornwall, c. 1905.

pilchards, and acceptable to Italian taste, the sardines needed to be at least 20 cm (8 in.) long.

Relics of the importance of the pilchard industry are scattered far and wide in Cornwall and Devon. The emblematic seal for the City of Truro in Cornwall, incorporated by Elizabeth I in 1589, is a fishing boat with two pilchards beneath the waves.[11] A Looe token, a form of local currency for bartering goods, dating from Charles II's era (1630–1685), depicts a pilchard.[12] In St Ives, high above the bay a huer's house is still preserved – a building substantial enough to show the importance of this role. A huer in the 1880s would be paid about £3 a month during the fishing season and commonly receive 1 per cent of the fish caught under his guidance.[13]

Hogshead barrels are filled with salted pilchards. St Ives, Cornwall, c. 1905.

In 1870, at the height of the industry, 379 Cornish seine nets were recorded, with 285 in St Ives. The largest ever catch by a British seine net was at St Ives in 1868; 5,600 hogsheads, which at about 2,500 fish per hogshead equates to 14 million fish! This catch alone realized more than £11,000 at the time.[14] In the 1850s some 20,000 to 30,000 hogshead barrels of salted pilchards were exported each year from the St Ives pilchard fishery alone. While in the economy of Britain overall, the Cornish pilchard fishery might appear small-scale, to the inhabitants of this remote and rugged landscape this marine harvest was a reliable and vital source of income and protein for several centuries.

A coin-like token, used for bartering goods in Looe, Cornwall, in the mid-17th century, features a pilchard.

Dr John Wolcot (1738–1819), who wrote under the pen name Peter Pindar, expressed the Cornish fishing communities' passion for the pilchard in a poem, revealing his particular enthusiasm for the exclamation mark:

Pilchard! A thousand times as good as a herring!
Pilchard! The idol of a Popish nation!
Hail! Little instrument of vast salvation!
Pilchard! I ween a most soul-saving fish
On which the Catholics in Lent are crammed,
Who had they not, poor souls, this lively fish
Would flesh eat, and be consequently damned.
Pilchards! Whose bodies yield the fragrant oil
That makes the London lamps at midnight smile.[15]

The emblematic seal for the City of Truro, Cornwall, reflects the importance of pilchard fishing to the local economy.

As with any commodity, all manner of people wanted their cut of the pilchard action. Churches wanted a tithe (normally 10 per cent or less of the catch, or its equivalent value in cash). The government taxed the salt used to preserve the fish. Landowners might ask for rent from fishermen who landed on or moored alongside their property. There were many idiosyncrasies in the

way the industry was managed and legislated. Acts of Parliament, for example, privileged seine fishermen above drift fishermen, until seine fishing no longer proved profitable.[16] There were plentiful disputes and sometimes outright resistance. Cornish fishermen in the extreme southwest, who had trouble enough making a living with the sardine catch so unpredictable from year to year, resented paying a tithe. Repeatedly, in the eighteenth and early nineteenth centuries, they made representations to Parliament to abolish the tithe. Matters came to a head around Christmas 1830, when the annual tithe per boat was raised from £1 to more than £4. The first person who arrived to collect the tithe – a solicitor from St Ives – had to flee for his life under a barrage of stones, fish and snowballs. The second person – a Penzance bailiff called William Quick – armed himself with pistols, but was disarmed and given similar treatment. No further attempt was made to collect the tithes, and the local fishermen, celebrating victory, hoisted a board with the painted slogan, 'No tithe: one and all.'[17]

The demise of the Cornish pilchard fishery in the late nineteenth and early twentieth centuries, like that of other sardine fisheries, had multiple causes. Pilchards no longer swam so close to shore. According to Brian Stevens, curator of the St Ives Museum, several factors were likely responsible.[18]

In the nineteenth century Cornish mining for iron had coloured the local river water red and the run-off stained the coastal waters. This had two effects: the mineral-rich water probably fertilized the sea, improving plankton productivity and so providing more sustenance for the sardines; secondarily, the stained seawater helped shelter sardines from visual predators. As the Cornish mining industry declined, the waters cleared and the sardines stayed further offshore. The staining of seawater also explains why pilchards could be caught close to shore during the daytime

(normally they are caught only under cover of darkness, when they rise nearer to the surface and it is harder for visual predators to hunt them).

Stevens also suggests that the shift from sail-driven to steam-driven craft, and the increase in local tourism, would have heightened local disturbance in the near-shore waters. Overfishing would have contributed to the decline too, including the activities of drift-netters catching more of the fish offshore.[19] Climatic influences on water currents and sea surface temperatures might have played a part.

Whatever the specific combination of factors, by the 1910s, the nature of Cornish fishing had changed. Seining from shore, involving almost the whole community, had declined in favour of fishing further offshore using larger boats and fewer people. Drift netting and trawling offered the opportunity to catch fish of higher value than pilchards, such as hake, plaice, sole and whiting. This meant greater financial investment by fewer people, but funding a fishing industry with more uniform supply and demand. By this time England's railway network had extended too. Larger boats needed larger ports, and many of the pilchard villages became redundant. The rail network, coupled with the new technology of refrigeration, meant that high-value fish could be speedily transported in ice from Penzance and onwards, for distribution throughout England and by boat, to markets in Europe. This was a far cry from the slow transportation of salted fish in seeping barrels.

While the pilchard industry in Cornwall was declining, another sardine fishery half a world away was poised to take off. Along the coast of western North America, from Alaska and Canada in the north to Mexico's Baja California and the Gulf of California in the south, lives a subspecies of the Pacific sardine, *Sardinops sagax caeralea*. Slightly larger than the European pilchard, its

distribution shifts from year to year with temperature and shifting water masses. Historically, California has been the heart of the eastern Pacific fishery with Monterey Bay its pacemaker. The beginnings of the Californian sardine fishery are recorded in 1889, when a sardine cannery was set up in San Francisco. As early as the mid-1890s, Californian canneries made the sardine the number one canned fish in the United States by volume.[20]

By the early twentieth century, the beginnings of what was to make Monterey 'the sardine capital of the world' revolved around three characters: Frank E. Booth, a successful local fish canner; Knute Hovden, a fish packing specialist arriving from Norway; and Pietro Ferrante, or 'Pete' to those who knew him, a fisherman from Sicily. Booth and Hovden established the first canneries at Monterey Bay, while Ferrante massively improved catches by introducing the lampara net – a net for encircling a shoal and scooping them out, but without a fully enclosed bottom as in a purse seine. Ferrante invited Sicilian fishermen to Monterey to use it.[21]

In these early years, until the mid-1920s, fishermen caught sardines using gill-nets, beach seines and, from about 1907, the lampara net. The lampara fleet's catch was offloaded from towed barges into the canneries in steel buckets on moving cables.

The First World War proved a major spur to the development of the fishery. From 1914 much of Europe became embroiled in fighting, and exports of European sea fish dwindled to almost nothing. The United States was ready to take up the slack, and between the 1916–17 and 1923–4 seasons, although annual catches of Californian sardines fluctuated from year to year, they rose from nearly 25,000 tonnes to more than 76,000 tonnes.[22] This growth coincided with a federal government campaign promoting fish as a protein substitute for meat, since hostilities in Europe made meat much harder to obtain on the international

market. By 1919 nine sardine canneries were based in and around Monterey.[23] Its picturesque beach had become a smoky, smelly industrial landscape.

Fisheries research has its heroes, and one was the visionary William Francis (W. F.) Thompson (1888–1965). Between 1917 and 1925, while employed by the California Department of Fish and Game, he established its first marine fisheries laboratory and an agency for monitoring the state of its fisheries. Writing in 1926, he clearly set out the opportunity for California's sardine fishery, but leavened it with caution:

> There has been a truly marvelous development of the sardine fishery in California. Although it originated as a great fishery during the stress of the war, the industry has shown a vitality which augurs well for its permanence so long as the raw material is obtainable. The amount caught exceeds by far that taken by any other species in California, and there appears at present no other which is capable of the tremendous yield, unless it is the unused anchovy.
>
> Experience with older fisheries has shown that rational use demands a knowledge of at least two things. There must, above all else, be information from time to time regarding the manner in which the species is withstanding the strain of the fishery. But there must also be an understanding of the natural changes in abundance which inevitably occur, so that these may be distinguished from the effects of overfishing and also may be foretold and understood. Based on such knowledge, regulation and exploitation may be rational and restrained.[24]

The California Department of Fish and Game's policy was for fish to be caught commercially for human consumption, rather

than rendered into sardine oil and fishmeal, whether for animal food or as agricultural fertilizer. However, canneries produced plentiful waste material – discarded viscera and damaged fish – which could be processed into sardine oil and fishmeal. Sardine oil had a multiplicity of uses: in manufacturing paint, varnish, paper, fabric, linoleum, tanned leather, insecticides, candles and soap. Fishmeal could be processed into agricultural fertilizer or food for farm animals. By the 1920s improvements in technology meant that fish waste could be processed into a dry, more appetizing, less smelly form of meal, which had better keeping qualities and when fed to poultry or livestock would not taint the taste of the meat. Good-quality sardine oil was a by-product of this process.[25]

In 1926 two purse seiner boats arrived in Monterey Bay. Much larger than the lampara vessels, they were over 50 ft long, with large diesel engines and a power winch for hauling in the vast purse seine net – over 0.8 km long and as much as ten storeys deep. Within a decade the seiners would replace the lampara boats.

Catching sardines was highly skilled and was generally done by Sicilian fishermen, bringing with them generations of fish-catching knowledge. It was done at night with most of the ship's lights turned off, so as not to attract other fishing boats or scare the fish. The boat's skipper would look for the phosphorescence of disturbed plankton. Experienced skippers could distinguish the glow caused by sardines from that of anchovies or horse mackerel. Mistakes were costly. Anchovies, being smaller than sardines, would block the net, which would have to be taken back to port and cleared before reusing. Releasing the net, encircling the shoal, drawing tight the purse and then hauling in the net required great dexterity. If the sardines were too small, they were emptied back into the sea – usually dead.[26]

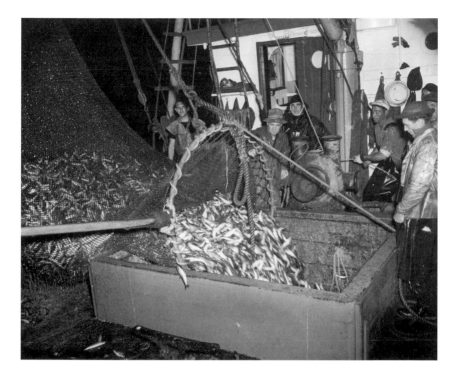

Alongside these larger vessels with their larger catches, Knute Hovden pioneered the use of underwater pipelines to pump the sardines from a floating hopper (a vessel into which boats unloaded their catch). From there, the sardines were pumped direct by pipeline into the canneries – a practice that rapidly became the norm.[27] Canning technology improved too, becoming more mechanized, especially for the soldering of the cans – the can's size a legacy from the days of canned local salmon.[28]

Ultimately, two-thirds of Monterey's sardine catch up to the mid-1960s would be turned into fishmeal and oil.[29] And it was the reduction plants – which turned fish heads, tails and entrails

Sardines being transferred by dip net from the seine net into the hold on board the seiner *City of Monterey* in the 1940s.

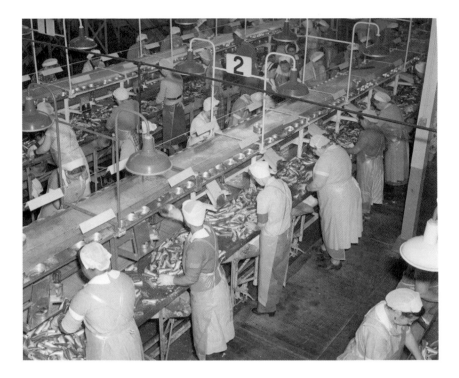

Women packing sardines into cans at the Cal Pac (California Packing Corporation) cannery. In 1945 nineteen canneries were operating in Monterey employing at least 8,000 workers overall.

(and later whole sardines) into oil and fishmeal – that produced Monterey's stink, not the canning processes themselves. Beneath the water of Monterey Bay, the discharge of decomposing fish waste from canneries caused such high levels of nutrients and fish oils that nearby it depleted the water's oxygen, killing most kinds of marine animals, plants and microbes.

Between the mid-1920s and the early 1930s California's legislation concerning the catching of sardines for fishmeal and oil became loosened, and poorly enforced, under pressure from commercial interests. Even before the Great Depression of 1929–39, entrepreneurs were asking the question, 'Why put sardines in cans

when we can make more money by turning them into oil and fishmeal?' There was resistance to this move from well-established canners and from scientists. As early as 1924, W. F. Thompson had written:

The sardine is a source of food for almost all our other great fisheries, such as albacore, barracuda, sea bass and tuna. Tampering with its abundance may result disastrously to many interests – and in the absence of any clear cut and sensitive method of detecting overfishing, the greatest caution must be used. The writer has convinced himself that unnecessary drain on the supply should be avoided until research has shown that it is possible to detect overfishing in time, and for that reason it is his belief that the use of sardines for fertilizer should be emphatically condemned, and a more conservative growth of the fishery awaited.[30]

Between the late 1920s and mid-1930s, year after year, scientists would write reports circulated to the California State Legislature and other interested parties, arguing that the fishery was being overfished and that annual catch limits should be set (variously, within the range 200,000–300,000 tonnes for the whole of California). Committees were set up, and reported back, but little or no legislative action was taken. Leaders in the fishmeal industry used delaying tactics, pressing eventually for federal and state agencies, in association with the Scripps Institution of Oceanography, to conduct large-scale oceanographic studies to better understand the wider factors affecting the sardine fishery. While such studies would later prove invaluable, they served as a distraction from taking immediate action to better regulate the fishery, and specifically, to reduce the annual sardine catch.[31]

In 1931 N. B. Scofield, another leading light in the California Department of Fish and Game, called 'N.B.' by his colleagues, wrote:

Off Monterey, in the 1930s and 1940s, sardine catches could be so bountiful as to fill both hold and deck, as in the case of this seiner, *Western Explorer*, in the late 1940s.

Although the amount of sardines caught has been increasing each season, the catch has not increased in proportion to the fishing effort expended, and there is every indication that the waters adjacent to the fishing ports have reached the limit of their production and are already entering the first stages of depletion. The increase in the amount of sardines caught is the result of fishing farther from port with larger boats and improved fishing gear.[32]

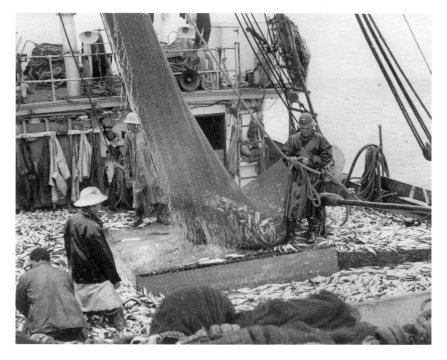

These are the classic early signs of an overfished fishery. Put simply, overfishing is when the number and type of fish taken each year is greater than can be replenished naturally. The weight of fish caught by applying a certain degree of fishing effort declines, and this goes hand in hand with a fall in the overall numbers of fish in the targeted population. In this case, the fish catch from local waters declines, and fishermen have to go further afield to maintain their returns.

Another sign of overfishing, reported in 1939 by the pioneering female fisheries biologist Frances N. Clark, was that the sardine's average lifespan had fallen from ten years to four over thirty years of commercial fishing.[33] The fishery was relying on three- and four-year-old fish, both to catch and to replenish fish stocks through breeding. This meant that the fishery had little resilience, and should environmental conditions cause a year or two of poor breeding and recruitment, there would be few older fish left to reproduce and replenish stocks in years when conditions became more favourable.

In 1929–30 the Californian sardine catch was more than 290,000 tonnes, peaking at a monumental amount of more than 640,000 tonnes in 1936–7. The 1930s and '40s were the golden era of the fishery. In 1945 Monterey hosted nineteen canneries and twenty reduction plants, the fishing fleet had risen to more than a hundred vessels, and Monterey had become the third-largest fishing port in the world.[34] However, all was not well.

In 1952–3 the fishing season was catastrophic. Only about 6,500 tonnes was landed, a decline of some 94 per cent on the previous season. In the decades that followed, despite more efficient fish-catching technology, annual landings of Pacific sardines from Mexico to Canada would not rise above 100,000 tonnes until 2002. Since then, the catch peaked at some 127,000 tonnes in 2007, but then plummeted to 23,000 tonnes in the 2014–15 season, with

Part of Monterey's fishing fleet at anchor in 1940. The larger vessels are seiners. Around this time the sardine fleet numbered more than 100 vessels.

fishing bans in force for most of the 2014–15, 2015–16, 2016–17 and 2017–18 seasons.[35] At the time of writing (June 2017) no Pacific sardines in the u.s. range of the fishery were allowed to be caught commercially.

It is the sardine-canning district of Monterey of the Depression-laden late 1930s that is the locale captured in John Steinbeck's novel *Cannery Row*, published in 1945.[36] In 1939 the canneries were nestled in a strip of Ocean View Avenue, affectionately called Cannery Row. In fact, neither the canneries nor their workers are the book's focus. Steinbeck's novel deals with the 'out of hours' Cannery Row:

> The canneries rumble and squeak until the last fish is cleaned and cut and cooked and canned and then the whistles scream again and the dripping, smelly, tired Wops

and Chinamen and Polaks, men and women, straggle out and droop their ways up the hill and into the town and Cannery Row becomes itself again – quiet and magical. Its normal life returns.[37]

The foreword to *Cannery Row* reads 'The people, places, and events in the book are, of course, fictions and fabrications.'[38] In fact, many of the book's locations and characters are only too real, and they are celebrated in the tourist quarter of modern-day Monterey.

*Cannery Row* revolves around the much-loved character 'Doc' who owns the Western Biological Lab. Doc is modelled on the real-life pioneering marine ecologist Ed Ricketts.[39] The book takes the reader on a mini-misadventure as Mack and the boys – a group of young men on the edges of society, but at the heart of Cannery Row – decide to throw Doc a party. This involves catching hundreds of frogs, which they can sell to Doc for five cents apiece to raise the funds. After convoluted escapades, during

Ocean View Avenue in 1945, the heart of Monterey's sardine canning and processing industry. This is the locale for the novel *Cannery Row*.

Ed Ricketts, photographed in 1935. Pioneering marine ecologist and John Steinbeck's model for 'Doc' in *Cannery Row*.

John Steinbeck, author of *Cannery Row* and friend of Ed Ricketts, at work in 1935.

which they drive a van backwards, get drunk and flounder in a frog-filled pool, they barter their frogs for provisions in Lee Chong's grocery store on the understanding that Lee Chong will be reimbursed by Doc. On the night of the surprise party, invited and uninvited guests consume all the food and drink. In an ensuing fight between Mack and an uninvited drunk, the container of frogs is damaged and they eventually escape: 'For quite a while Cannery Row crawled with frogs – was overrun with frogs.'[40] Doc arrives back late to find the party is over and he is left to clear up the destruction.

A gloom descends over Cannery Row, which by degrees gradually lifts: 'Now a kind of gladness began to penetrate into the Row and to spread out from there.'[41] The book culminates with Mack and the boys rerunning the party with greater success – and Doc is actually there. It ends with Doc musing wistfully on life's ironies as he clears up the mess the day after.

Paradoxical and charismatic, Ed Ricketts, the real-life 'Doc', had two wives, three children and many women in his life. Adults and children were drawn to him, with the children calling him 'Doc' when he treated their minor injuries. Ed eked out a living catching and preserving biological specimens and supplying them to schools, scientific laboratories and universities. At the same time, he was intrigued by wider and deeper matters and had an unusually holistic vision, merging biology, metaphysics, art and literature. He studied the biological communities on the beach at a time when biologists preferred to focus on individual species. His book *Between Pacific Tides*, published by Stanford University Press in 1939, described the biological communities on the shore in the zone intermittently exposed by the tides – the intertidal zone. It has become a classic in the field.[42] Ed's voice echoed that of many of the local scientists in foreseeing the demise of Monterey's prolific sardine fishery, at least in the short term. In a letter to a friend in October 1946, and referring to overharvesting and a recent drop in sardine catches, Ricketts writes: 'But in the long run, the sardine perhaps won't be hurt. Our policy of insisting on taking everything at the moment, free enterprise at its freest, hurts only us.'[43]

Susan Shillinglaw, a scholar of Steinbeck's work, draws parallels between *Cannery Row*'s setting and characters and the natural world. Its personalities, through their actions, and through the checks, balances and subtle shifts in the local community, behave as inhabitants of a natural ecosystem – such as a seashore tidal pool.[44] In 1940 Ricketts had written: 'Who would see a replica of man's social structure has only to examine the abundant and various life of the tide pools . . .'.[45]

Steinbeck and Ricketts met in 1930, their work intersecting science and art. Ricketts found it harder to write but had a deeper intimacy with nature, and shared his insights with Steinbeck. Together they went on many seashore expeditions to collect

specimens, in 1940 travelling to Mexico's Baja peninsula to do so. Their expedition aboard a sardine purse-seiner, the *Western Flyer*, is documented in their *Sea of Cortez: A Leisurely Journal of Travel and Research* – part travelogue, part philosophical musings, part detailed catalogue of specimens along with ecological observations. Their book straddles the two cultures – sciences and the humanities – more than fifteen years before C. P. Snow's influential Rede Lecture bemoaning the prevailing separation between these disciplines.[46] *Sea of Cortez* begins:

> The design of a book is the pattern of a reality controlled and shaped by the mind of a writer. This is completely understood about poetry or fiction, but it is too seldom realized about books of fact . . .
> We have a book to write about the Gulf of California. We could do one of several things about its design. But we have decided to let it form itself: its boundaries a boat and a sea; its duration a six weeks' charter time; its subject everything we could see and think and even imagine; its limits – our own without reservation.[47]

Steinbeck and Ricketts' difficulties in hiring a sardine fishing boat captures the single-mindedness of many sardine fishermen at the time: 'They were uneasy about our project. Italians, Slavs and some Japanese, they were primarily sardine fishers. They didn't even approve of fishermen who fished for other kinds of fish.'[48]

Ed Ricketts died in 1948 at the age of fifty, his stalled old Buick being struck by the slow-moving Del Monte Express train as he tried to restart the car.[49] Ed's nature – calm determination combined with impulsiveness – probably decided his death. Had he escaped from the car earlier, or simply remained in it, he might have survived. Trying to leave the vehicle just as the train struck

caused him to be crushed between the car door and door post, sealing his fate.

By the early 1950s the canneries were being dismantled and the parts sent to newly emerging fisheries in Peru, Venezuela and South Africa. Tourists began coming to Monterey Bay to see the places captured in Steinbeck's novel – Doc's lab, Lee Chong's market, Dora Flood's Bear Flag Restaurant and bordello, and the overgrown lot the Palace Flophouse, where Mack and the boys dreamed and drifted their lives away. In 1958 the City of Monterey officially changed the name of Ocean View Avenue to Cannery Row.

The Cornish pilchard fishery and California's sardine industry are but two scenarios that have been played out in a similar fashion across the world: in northwest France, Japan, South America, South Africa and Namibia. In all, the burgeoning twentieth-century exploitation of sardines has been followed by a steep decline – sometimes temporary, sometimes seemingly permanent.[50] In Australia in 1995 and 1998–9, two mass mortality events were caused by a Pilchard herpesvirus (PHV) outbreak. Each event killed more sardines, over a wider area, than any other recorded fish kill for a single species.[51] The sardine stocks have largely recovered since.

In southern Africa, with the Atlantic Ocean on its western flank and the Indian Ocean on its eastern, two fisheries have together surpassed even the Californian fishery at its height. Both fisheries are based on the Benguela upwelling, which brings cold, nutrient-rich water bursting to the surface, fuelling an explosion of plankton growth.

The northern Benguela fishery, off Namibia, and fed by the northern Benguela Current, was, until recently, one of the world's most prolific fishing regions. Traversed by large hunting predators – tuna, billfish such as marlin, sharks and an assortment of whales and dolphins – it has supported record catches of

sardines and anchovies. In 1968 about 1.4 million tonnes of sardines were landed. But by 1969 catches had nose-dived. The southern Benguela fishery, off South Africa, fed by the southern Benguela Current, showed a similar pattern of exploitation. By 1966, with its sardine catch peaking at about 410,000 tonnes in 1962, its fishery too went into steep decline.[52]

What happened next was influenced by fisheries management policy. A fortuitous experiment offers evidence that judiciously managing a fishery can make a difference. South Africa's and Namibia's fisheries both turned to anchovies, which could be caught by similar methods to those for the sardine. The southern sardine and anchovy fisheries have prospered under careful management, whereas the northern fisheries, adopting a different strategy, have not. As will we see later, the fate of sardines is often bound up in the destiny of another fish, the anchovy. And beyond this, harking back to Ed Ricketts and his holistic vision, no longer can the pursuit of a fish species be considered in isolation.[53] The entire regional ecosystem of which the fishery is a part needs to be taken into account.

# 4  To Eat a Sardine

My first culinary encounter with a sardine was as a young boy in the early 1960s in West London. I don't remember eating any other kind of tinned fish – not herring or salmon. My mother would buy tins of Portuguese sardines each wrapped in bright yellow card. They came from white-tiled Sainsbury's stores that had yet to become supermarkets. They were friendly places where the shop assistants were inordinately polite, smiled at you and wore white hats and overalls; places where they still patted butter and wrapped your pat in greaseproof paper. Tins of sardines were one of the few things that were not weighed or measured and packed by sales staff. Like baked beans, they came pre-packaged.

For a six-year-old, tinned sardines in oil squashed onto two slices of toasted white bread were a complete meal. In contrast to any other canned food we ate, they were savoury, not sweet. By the time they arrived on the plate they had been crushed almost beyond recognition. Nevertheless, I was still curious enough to conduct a post-mortem, teasing out the grey flesh and seeking to discover what the patches of varying colour and texture might be in the living fish. The piece I usually extracted was the backbone. The other bones would melt away to the bite, but the backbone would stubbornly maintain its gritty texture. I'd heft it to the side of the plate – a blue-grey bracelet of jetsam on the plate's shoreline.

As for the sardine's taste, it was salty, tangy and edgy. Not too fishy. Quite exotic compared to what we usually ate; but reassuringly, still a taste of home.

For Max Adams, writer and archaeologist, eating sardines has strong associations.[1] As a child, eating tinned sardines in tomato sauce was a rather synthetic, not particularly appetizing prospect. As a field archaeologist and mountain trekker, tinned sardines became a staple provision on expeditions. They could be blended in strange combinations to add a healthy, robust, protein-rich complement to bland foods. Hiking in the Corsican Alps, the sardine, Bombay mix and banana baguette became legendary.

For Max, the pinnacle of sardine eating isn't the baguette combo; it's the fresh fish, first experienced on holiday when cooked by his stepmother in Santa Fiora, Tuscany. Small sardines (less than 15 cm long) were gutted, rolled in flour and flash-fried in olive oil until crisp – as you would whitebait. Max remembers eating them whole, head and all, with a glass of robust local red wine. Still today, if Max is in the Mediterranean region, and sardines are on the menu, he usually eats them in preference to any other fish. 'Fresh sardines smell of the sea,' he says. 'Flash-fried they are crisp, meaty, unfussy food. Sprinkled with salt and cut with lemon juice, a perfect complement to bread and green salad. They are the sea's fast food . . . guiltily good.'

Being small, and given the oil-rich nature of their flesh, sardines 'go off' quickly. The Romans salt-cured them and since at least the fifteenth century, salt-cured Cornish pilchards were packed and sent across Europe to France, Spain and Italy. The method – adapted from that for herring – involved gutting and cleaning, sprinkling with salt and then laying them in barrels with more salt sprinkled between each layer of fish. Even oilier than herring, pilchards were pressed into the barrel so that some of the oil oozed out. Brine was then added to top up the barrel and

the lid closed. In this form, with the fish bathed in salt and their own oil, they could remain preserved for several months.[2]

The technique in Cornwall remained essentially the same for four hundred years or so, except that by the nineteenth century pilchards were cured in large piles between layers of salt for several weeks, before the fish were cleaned and barrelled. In the barrel, the fish were arranged in a circle, with the heads pointing out. Pressure was applied to the top of the filled barrel by a lever system, which squeezed oil out of the fish. This process was repeated three or four times, with the barrel topped up with fish each time. About 2,500 pilchards could be pressed into each hogshead barrel, with at least 2 gallons (9 litres) of oil recovered. By the 1870s, some 5,500 hogsheads, or 18 million salted fish, were being exported annually.[3] In Cornwall sardines were serious business.

In France sardines were even bigger business. By the sixteenth century, sardines caught off the Breton and Vendée coasts were a speciality of the Nantes region, salted and then preserved in vinegar, olive oil or melted butter in large earthenware jars called *oules*. In the seventeenth century the French treasury began collecting taxes from the sardine producers and from the sale of by-products, including the train oil for lamps and for tanners and the manure made from fish debris. By the eighteenth century, the salted sardine jars were replaced by wooden casks, and many towns and villages in Brittany were pressing sardines for delivery to Nantes and Bordeaux, or for export to Spain. In one year Port-Louis in the Morbihan region reputedly exported 40 million sardines in casks.[4]

France too is the originator of that most familiar container for sardines – the can or tin. The origins of canning to preserve many foods, not just sardines, can be traced back to the French chef and confectioner Nicolas Appert (*c.* 1750–1841). As with many inventions, the can or tin was a product of necessity. By

the early nineteenth century, Emperor Napoleon's army numbered hundreds of thousands and keeping them all fed was a formidable challenge. The French government offered 12,000 francs in prize money for a means of preserving food to distribute to troops. Appert won the prize in 1810 after showing that freshly cooked food could be put in glass containers, with the containers put in boiling water and then sealed and cooled. The food would remain palatable for months.[5] It was not until much later that Louis Pasteur would show that it was killing microbes, and then keeping them excluded, that was keeping the food fresh. The heating process also destroyed the natural enzymes in fish that would otherwise cause the flesh to digest itself.

By the 1810s Appert's technique was being applied to containers made of tin-plated iron, with the lid soldered on using lead, which is toxic. A hole was left for air and steam to escape. After cooking, but while still hot, the hole was sealed.[6] The containers were immensely heavy – often heavier than their contents – and needed hammers and chisels to open them. Manufacturers eventually replaced the lead solder with benign tin. Only in the mid-nineteenth century, with the development of steel electroplated with tin, could containers be made thinner and small can openers or a special tab and key be used to cleave them.

The first record of sardine-canning comes from about 1820, with Nantes confectioner Joseph Colin packing about a hundred sardines in olive oil into each tinplate-soldered box. The sardines could be kept preserved for more than two years. Such sardines formed part of the provisions that sustained ship's crews, including that of French Captain Freycinet returning from a thirty-month circumnavigation of the globe in 1822.[7] In tins, if not in shoals, sardines have probably travelled further than any other fish. Nineteenth-century tribesmen in arid Central Asia who had never seen a fish, let alone tasted one, savoured their

Best-selling Portola canned sardines when Monterey was the 'Sardine capital of the world'. U.S. sardine cans were about twice the size of European ones.

first when European explorers arrived with canned sardines in their provisions.

Between the 1850s and 1880s the French sardine canning industry expanded enormously. By 1861 Nantes canners were producing more than 100,000 cans of sardines a year. In this region alone the industry supported at least 15,000 fishermen plus 4,000 women in canning factories. By the 1880s about 160 sardine-canning factories were operating between Brittany and the Gironde region around Bordeaux. Despite increasing competition from abroad, and especially in Portugal and Spain where sardine supplies were more reliable, France continued to be a successful exporter because of the perceived high quality of its produce. At its peak in 1900 about 5,200 sardine fishing boats crewed by 23,000 fishermen were landing more than 50,000 tonnes of fish. After 1902 the sardine disappeared from French Atlantic waters, and the sardine fishing industry consequently collapsed, although

many canners still remained open, utilizing imported sardines or canning other kinds of product.[8]

By the 1930s several sardine canneries had opened up in North Africa, notably in Morocco. During the twentieth century, France's production of tinned sardines ebbed and flowed, depending on the intermittent return of the European sardine to French waters and the protectionist policies of competing sardine-canning nations, especially Portugal, Spain and the United States. By the early 2000s France had become a net importer of sardines for canning, getting most of its supply from Morocco, Portugal and Spain. In 1890s France a tin of sardines was a luxury item. An unskilled female factory worker would have to work for six hours to purchase one tin. In 1990 twenty minutes of labour from a worker on minimum wage would be sufficient.[9]

At the beginning of the twentieth century, with the decline in French sardine stocks, Portugal massively expanded its canning operations to exploit its own local sardines, but drawing upon French expertise. By 1917 more than 180 canneries were operating in the Algarve region. As elsewhere, Portuguese stocks of European sardines have expanded and contracted in the last 150 years, forcing displacement of jobs to other industries when the sardines become scarce. Notable periods of scarcity were in 1924–34 and in the late 1980s and 1990s. The industry then revived, but crashed again. In 2014 the Marine Stewardship Council (MSC) withdrew certification for the Portuguese sardine seine net fishery on the grounds that the annual sardine catch was not being regulated at sustainable levels for the small stock size.[10] In the early 1990s the fish-loving Portuguese consumed on average about 5 kg of fresh sardines each per year, compared to only 1 kg of canned.[11] Given the local sardine scarcity, they now import sardines from Morocco and Spain to maintain high levels of

consumption, and to keep their canneries busy producing tinned sardines for other parts of Europe.

Morocco is now the world's number one sardine catching and canning nation. Its labour is cheaper than in Europe, it has plentiful sardine stocks, and it catches them using sustainable methods that meet the scrutiny of the Marine Stewardship Council. In 2013 its fleet of coastal seine netters and deeper-water pelagic trawlers caught more than 1 million tonnes of mostly European sardines (with some *Sardinella aurita* and *Sardinella maderensis*) from the Atlantic Ocean and southern Mediterranean. In that year the Moroccan government granted licences to Russian trawlers, which caught about 80,000 tonnes.[12] It occasionally awards fishing licences to Spain. Many of the sardines

Fresh, bright-eyed sardines are a well-loved fish in Portugal, here on sale in a Lisbon market.

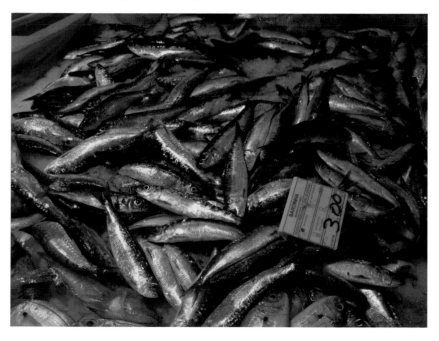

that are not eaten fresh or canned locally are freshly frozen and exported to Portugal and Spain, where they might be eaten fresh or sent to canneries.[13]

Today most sardine tins are made of coated aluminium. The ring pull has rendered almost obsolete that troublesome key that hooked into a metal tab and rolled back the lid. Reassuringly, modern cans – whether aluminium or steel – have an excellent safety record. Usually the 'use by' date on a can is five years from

Tinned sardines in brine.

A modern sardine can with ring-pull tab.

manufacture and the can's metal is recyclable.[14] Tinned sardines are fashionably 'green'.

In modern processing methods, fresh sardines are descaled and the head, tail and entrails are removed – formerly done by hand, but now mechanized – a process called 'nobbing'. The offcuts go to a fishmeal plant. The carefully packed fish are normally precooked at 90–100°C in open cans; the liquor (a mixture of oil, water and soluble protein) is removed and also sent to a fishmeal plant, where the oil is separated and the soluble protein added to fishmeal.

Tinned sardines are typically weakly acidic (pH 6–7) – conditions which favour the growth of potentially harmful microbes such as *Clostridium botulinum*, responsible for botulism. Further treatment at high temperature removes that risk.[15] After filling the can with an appropriate medium – brine, oil or some kind of sauce – the can is sealed and heated at 117–121°C for some 60–110 minutes, depending on the size of the can and the nature of its contents.[16] The finest sardines are fried or grilled before canning

Modern tinned sardines are available in many forms as delicacies.

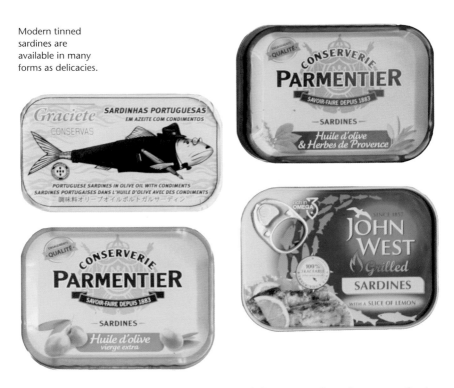

or, after canning in oil, are left to mature for at least a year for the bones to soften and the flavour to develop. Most French connoisseurs think high-grade tinned sardines are at their best after maturing for two or three years.

When I recently visited a high-end supermarket in a small town in southwest England, the canned fish display had five shelves dedicated to tuna, two to salmon and three to sardines – a snapshot of the modern eating habits of English consumers. On the sardine shelves, buyers had a choice of 27 products. Weight for weight the cheapest sardines were about one-sixth the price of the most costly. You could have utilitarian tinned sardines

in water, tomato sauce, olive oil or sunflower oil. At mid- to high prices, your choices included sardine fillets (skinless and boneless) and grilled sardines, with more delicate sauces, such as virgin olive oil with added piquancy: lemon, basil, sundried tomatoes, chilli or Herbes de Provence. Most of the sardines were Portuguese with a few from Morocco and in one instance, and the most expensive brand, from Cornwall. Weight for weight, tinned sardines are cheaper than salmon or tuna. But there are other compelling reasons for eating them.

Fish, in general, are excellent sources of readily digestible protein, minerals such as calcium, iron, phosphorus, potassium and magnesium, plus vitamin B12. Like other oily, dark-fleshed fish – tuna and salmon, for example – sardines are rich in omega-3 fatty acids and fat-soluble vitamins A and D.

So-called white fish, including North Atlantic cod and flatfish such as sole, have flesh which on cooking is pale. Unlike oily fish, they store oil rich in omega-3 essential fatty acids in the liver rather than the flesh. Today eating fish liver is less fashionable than it was. Swallowing a spoon of bitter-tasting cod liver oil was once regarded as an elixir – fending off all kinds of ills. Rich in essential fatty acids and oil-soluble vitamins, it was an excellent health supplement long before the excitement about omega-3s. Today eating oily fish is a much more enjoyable way of gaining similar benefits.

In epidemiological studies and clinical trials, regularly eating the flesh of oily fish is found to be associated with lower blood pressure and reduced blood cholesterol as well as a decreased risk of heart attack and type-2 (late onset) diabetes.[17] The body uses essential fatty acids to manufacture certain proteins for neurones (nerve cells), including those found in the brain. In the 1990s initial studies showed low consumption of omega-3 essential fatty acids to be associated with depressive symptoms, and even violent

and other forms of antisocial behaviour. Blind-trial experiments altering the diet of young offenders (some being given omega-3 supplements and others identical-looking placebos) revealed fewer offences among those who took the active supplement. Omega-3 essential fatty acids became popularly dubbed 'brain food'. However, that early promise has yet to be fulfilled, and recent systematic medical reviews have not confirmed psychological and behavioural benefits.[18] The cardiovascular benefits are well supported, though, as are the benefits of plentiful omega-3 fatty acids in foetal development, so an adequate supply in pregnant mothers is important.[19] Deficiencies in omega-3 essential fatty acids can be compensated for by taking supplements, but why take supplements if you can eat oily fish?

But, tinned or fresh, why eat sardines in preference to more fashionable oily fish, such as tuna, salmon or swordfish? I would choose the sardine because it is more environmentally 'green'. Sardines can be caught and processed with less wastage than almost any other food fish. Being low in the food web, sardines are efficient at converting their nutriment into flesh.

Sardines occupy a position in food webs below that of large marine predators. As a rough guide, 90 per cent of available biomass (mass of living tissue) is lost in moving down from one trophic (food) level in a food web to the next. So, the total mass of large predators such as tuna, swordfish and salmon in an ocean region is much less than that of sardines and other small fish on which they feed. As predators ourselves, we have less impact on the health of marine ecosystems if we eat small rather than large fish.

For purposes of comparison, tuna is an appropriate large fish. Most tuna stocks have declined dramatically in the last thirty years. In 2009, of international stocks of seven tuna species, about 33 per cent were being over-exploited and 37 per cent fully

exploited.[20] The bluefin tuna, which can grow to a staggering 680 kg (1,500 lb, heavier than a racehorse), is in high demand. A single large specimen was sold at a Tokyo fish auction in 2013 for a record-breaking U.S.$1.7 million – $7,600 per kg – to be turned into the world's most expensive sushi.[21] In 2014 the North Pacific bluefin tuna was assessed as being heavily overfished and the fish stocks at only 4 per cent of historic unfished levels.[22] In that year, among the seven principal tuna species, 41 per cent of the stocks were estimated as fished at biologically unsustainable levels.[23]

Tuna, occupying a high level within food chains, lay down their flesh from hundreds of prey they have eaten, which in turn have eaten hundreds or thousands of prey. In the process, heavy metals can accumulate. Some stocks of tuna show high levels of mercury in their flesh, so health authorities set safe recommended limits

'Fishing down the food web' is a term introduced by fisheries expert Daniel Pauly. It refers to the tendency for fishers to target larger species only concentrating on smaller ones when larger species are scarce. On balance, it is ecologically more efficient to target smaller fish such as sardines.

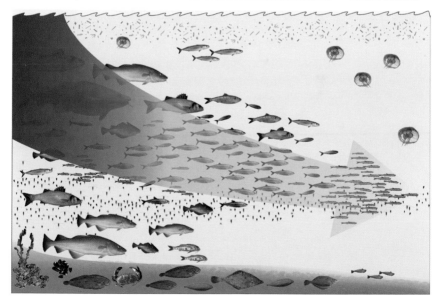

on tuna consumption. Sardines store much lower concentrations of heavy metals and it is safe to eat them regularly.

The salmon you eat, whether tinned or fresh, are likely to have been farmed in pens at high densities, releasing waste products and uneaten food that can cause local pollution. Worldwide, the high incidence of parasitic lice among farmed salmon – nowadays controlled by chemical treatment – may have had a catastrophic effect on the populations of wild salmon in the vicinity. Farmed salmon escaping and breeding with wild salmon can lower the vitality and survival traits of wild fish.[24] Typically, it takes 3 kg of sardines or other small fish to produce 1 kg of farmed salmon, Given the recent high prices of fishmeal, alternatives are being explored. If you do eat tuna, a Marine Stewardship Council (MSC) label marks tuna that has been caught responsibly from sustainable fisheries, while salmon, farmed with good practice, should carry the Aquaculture Stewardship Council (ASC) logo.

Fishing methods too vary considerably in their destructiveness. A well-regulated sardine fishery has less impact on the environment than fishing for almost anything else. Because a sardine shoal can be accurately encircled with a net, there is much less likelihood of by-catch – catching unwanted fish and other sealife that are killed and wastefully discarded. All in all, the sardine is a wholesome, healthy and environmentally friendly food. Across the world, vested organizations typically rank sardines in the highest category for healthy eating and – depending on the stock – with moderate to high status for sustainability.

No book about the sardine would be complete without describing how you can prepare the fresh fish for cooking. Given an uncooked, unprocessed sardine, how can you tell how fresh it is? If it is bright and sparkling, and it looks as though it could swim away, it has probably been caught a few hours ago or has been well preserved in ice for up to a day. The older it is, the duller it

looks. The eyes become opaque, the scales lose their sheen, the fins harden and the gill filaments clump together and turn grey-brown. A fresh fish should barely smell of fish at all.

When preparing a bright-eyed fresh sardine, rub the scales off with your thumb and rinse the fish under cold running water. To remove the viscera and gills simply cut a strip of flesh a few millimetres wide from the underside of the fish using a sharp knife or stout kitchen scissors. With body cavity opened up, slide your thumb from tail to head, removing the guts and gills as you go. Dry the fish inside and out by patting with kitchen tissue. Now it is ready for grilling.

If you hate extracting bones from a cooked sardine, 'spatchcocking' will remove most of them. Extend the slit in the underside of the fish beyond the vent to the tail. Turn the fish onto its belly with the flesh splayed out on either side. Now, starting at the tail, press down gently but firmly on the back of the fish with the palm of your hand, working from tail to head, so that the backbone of the fish is pressed down towards the chopping board. The aim is to exert just enough pressure to cause the backbone, and the other bones attached to it, to ease slightly away from the flesh. Now turn the fish belly up and, starting at the tail, tease the backbone and attached rib bones from the flattened flesh. Cut through the backbone with knife or scissors as close to the head as possible, and lift tail and bones away. Any bones left behind are likely to be the smallest ones.

The simplest way to cook sardines – and popular across the world – is to lightly smear them in a good-quality vegetable oil and simply grill or barbecue them at high heat for 2–3 minutes on each side. When grilling, place them on a lightly oiled baking tray. When barbecuing, clamp the fish in a wire grill basket so the fish can be easily turned without tearing them. Given the distinctive taste of sardines, most chefs recommend not overpowering the

flavour with another one, but complementing and accentuating it with herbs, oil and lemon. Freshly grilled sardines have a sesame nuttiness with a hint of smoked aubergine. Their distinctive flavour makes them one of the few fish that is better complemented with a robust red wine, rather than a white.

Grilled sardines as a gastronomic treat have undergone a revival in Europe and North America, with the resurgence of stocks in the North Atlantic and North Pacific, and with growing awareness that the stocks of many other traditional food fish are threatened. English pilchards, previously poor man's fare, are now upmarket 'Cornish sardines', while on the U.S. East and West Coasts fish aficionados import fresh Portuguese sardines as a delicacy. It is hard to imagine something you could not eat alongside grilled or barbecued sardines. Bread, pasta, rice, eggs and salad all fit the bill well. And so, at a pinch, do potatoes and pulses.

Grilled sardines with green salad and boiled potatoes are common fare in Mediterranean countries.

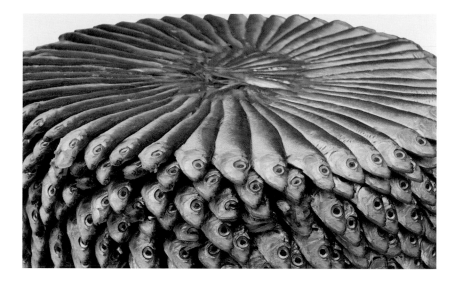

Salted sardines are still a speciality in Italy, packed in circular boxes.

Salted sardines – in continental Europe until the early twentieth century, a favoured method of preservation – have largely gone out of favour. The last Cornish pilchard salter closed in 2005.[25] In Italy Sardinian salted sardines are still produced on a small scale for a gourmet market. Given that fresh sardines are readily available in season, and the availability of a wide range of specialist canned sardines, the texture and flavour of salted sardines has become less acceptable to the modern palate, and extra work is involved in preparing them in food dishes.

One Cornish tradition still persists: the recipe for Stargazy Pie is hundreds of years old. Gaining its name from the circle of sardines that poke their heads through the pie's pastry – an arrangement similar to that of barrelled pilchards – the other contents of the pie can include meat and in-season local vegetables. Food writer David Mabey favours adding apple, bacon and pickled rock samphire, a coastal plant.

Stargazy Pie is a traditional Cornish delicacy, named after the fish heads that gaze out of the crust. In this example, other fish have replaced sardines.

Modern sardine recipes bring in influences from across the world. Media chef and fish conservation campaigner Hugh Fearnley-Whittingstall has created a sardine escabeche (from the Spanish for 'pickled') with strong seasoning from Spanish and Moorish traditions: caraway, chilli, coriander and cumin. Fresh sardines are patted dry, sprinkled with the spice mixture, and then gently fried. They are transferred to a deep dish, and a marinade made from fried onions in wine and vinegar combined with a spice mixture is then added. After cooling and then chilling in marinade for several hours, the sardines are best eaten at room temperature or slightly warmed.[26]

The French have taken cooking sardines to a fine art. Jacques Bonnadier in his celebration of the sardine, *Le Roman de la sardine*, includes more than 120 French provincial sardine recipes dating back to the late nineteenth century. They include thirteen types of stew and more than forty versions of stuffed sardines. There are recipes for sardines served with pasta, in aspic, in a marinade, plus inventive ways for either celebrating or disguising tinned sardines.[27] Historically, in different French regions the sardine garners

descriptive local names. Along the Atlantic coast, they include, in Normandy, *célan, célerin, hareng de Bergues,* or just the English name pilchard; in Brittany, *coureuse* or the larger fish *sardine d'hiver;* around Bordeaux, *chardine,* with smaller fish *sardinous* and larger, *chardinoun;* while close to the Spanish border, sardines may be *parrutcha.* Along the Mediterranean coast, other names emerge, with variations on *pelaya, poutine, sarda, sardella* and *sardino.*[28]

The Japanese are perhaps the most inventive in preparing and cooking sardines – whether eaten raw, fried, baked, pickled, steamed, smoked, shredded or ground. In the 1950s a Tokyo restaurant, Iwashiya, boasted more than fifty sardine recipes.[29] An unusual delicacy, dried and added to food dishes, are tiny sardines some 5 cm long. In Tokyo today several restaurants specialize in the sardine – one, Nakajima, is Michelin-star rated.[30]

Most people living in developed countries assume that the bulk of the seafood they eat is wild, and has been caught in the open ocean. This is no longer true. Since 1980 the weight of seafood and freshwater fish grown in some kind of farming operation

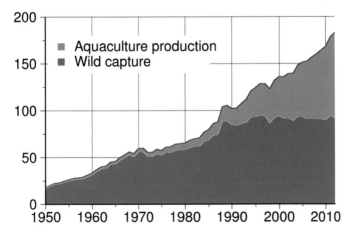

The level of wild capture of aquatic organisms (in millions of tonnes) has remained fairly constant since the mid-1990s, while the growth in aquaculture has been substantial (FAO data). Fishmeal made from sardines is a common ingredient in aquaculture feed.

(aquaculture) has increased twelve-fold. The annual amount of marine fish and seafood captured by fishers has not increased since the mid-1990s, despite improved technology.[31] This is because several of the world's major fisheries have collapsed. And when major marine stocks were assessed in 2011, about 29 per cent were still rated as being unsustainable – they were being over-fished.[32] With marine and freshwater produce in high demand, farmed fish and shellfish make up nearly half of the aquatic food consumed by people worldwide.

Even today, more sardines are processed into fishmeal and oil than are eaten whole. Processing involves pressure-cooking the fish or offal, extracting the liquid, separating out the oil and drying the remaining flesh.[33] The fishmeal and oil extracted from anchovies and sardines (and other pelagic fish too, such as herring) are common key ingredients in pellets fed to farmed fish and seafood such as shrimp.

Sardines are ideal hook bait used by anglers to catch large marine fish.

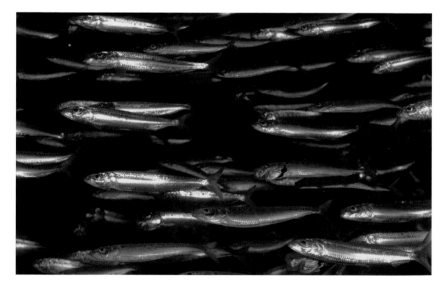

Increasingly, tuna are farmed in pens at sea. Commonly, they are fed sardines.

Some sardines are used as hook bait to catch all manner of high-value fish species, both for sport and commercially in long-line fishing. Californian sardines were, until recently, frozen in blocks and exported to Australia and Japan to be fed to bluefin tuna grown in pens.

The next time you eat a sardine, appreciate that more than half of its brethren caught by fishers won't have made it to the dinner plate, or at least not as a sardine. Many will have been converted into fishmeal and fish oil and fed to other fish. But why not eat the sardine? Fresh or tinned, a sardine will delight your palate and soothe your conscience.

# 5  Fortunes Lost

At the end of the nineteenth century there were still some eminent scientists who thought that marine resources were inexhaustible. Thomas Huxley, grandfather of the writer Aldous Huxley, at the opening of a Fisheries Exhibition in London in 1883 boldly stated that for British waters: 'the cod fishery, the herring fishery, the pilchard fishery, the mackerel fishery and probably all the great sea fisheries, are inexhaustible: that is to say that nothing we do seriously affects the number of fish.'[1] Even if that were true at the time – given the fishing technology then available – the situation was to change dramatically within just a few decades.

Walk around the Cannery Row district of Monterey today and you are seeing, on the one hand, a testament to the demise of the sardine, and on the other, a celebration of the author John Steinbeck and the pioneering ecologist Ed Ricketts. Some 3 km away, harboured in Monterey port, the local fishing fleet catch sardines when they can, but often turn to squid or mackerel. There are also opportunities to change to fishing for so-called ground fish (fish living near the sea bed) such as sablefish and rockfish, although these require very different fishing methods – trawling instead of seine net fishing.[2]

In 1951, when Marilyn Monroe was being filmed in a Monterey sardine cannery for the RKO feature *Clash by Night*, sardine catches were plummeting. By the early 1960s the fishing fleet fell largely

A modern mural depicting sardine fishermen from an earlier era in Cannery Row, repairing their nets.

The Cannery Row district of Monterey is a celebration of sardine fishing and canning, John Steinbeck and Ed Ricketts.

Thomas Henry Huxley (1825–1895), leading British biologist who claimed the fisheries around the United Kingdom were inexhaustible.

Sardine fishing is celebrated in this sculpture in Monterey Harbor.

into disuse and the canneries closed. The international market for fish abhors a vacuum, so when the Californian fishery collapsed, South African production of sardines and anchovies grew massively, as did that of Peruvian anchovies. The decommissioned fish-processing machinery from California was exported to those new markets. By the mid-1970s the Californian sardine fishery was showing signs of revival. Catches since, using highly efficient fishing technology with stringent fisheries management, remained, however, at roughly 10–20 per cent of those during the heydays of the 1930s, only occasionally rising above 100,000 tonnes between the years 2000–2013. But in 2014–15 the catch dropped to 23,000 tonnes, and with an assessment that the biomass of the entire sardine stock was less than 100,000 tonnes, the u.s. sardine fishery was closed down for the 2015–16 season. With the biomass still remaining low, commercial sardine fishing in u.s. waters has remained banned for the 2016–17 and 2017–18 seasons.[3]

The story of the exploitation of sardines, like that of so many other fish, is one of boom and bust, of finding ways to catch fish

in abundance, and then over-exploiting them until the stock collapses. California's sardine industry is just one of many well-documented examples of a boom-and-bust fishery.[4]

France, perhaps more than any other nation, has experienced the impact of the sudden disappearance of sardine stocks. In the mid-nineteenth century, once sardine-canning operations were well established, any shortage in sardine supply would swiftly bring hardship to many communities in northwest France. Off the Atlantic coast, 1846, 1852, 1858 and 1870 were particularly poor years for sardine catches. Then two prolonged bouts of sardine shortage – the years 1880–86 and 1902–7 – became *crises sardinière* that rocked the industry.

As is often the case, when a fishery becomes successful, it becomes over-capitalized – with too many fishing boats and fishermen to be sustainable. In 1903 the poet, novelist and historian Charles Le Goffic, writing in *L'Éclair*, commented:

The once-thriving but then derelict Hovden Cannery in Cannery Row. Photographed before 1968, prior to the area's refurbishment as a tourist attraction.

In ten years the number of boats and fishermen has almost increased by a third. Many agricultural labourers, even small farmers, have abandoned fields for the open sea. There are far too many sardine fishermen in Brittany, and we are beginning to realize it.[5]

In 1902 and 1903 catches dropped to less than 25 per cent of previous years. At the time, local authorities ascribed the absence of sardines to weather conditions – particularly strong storms in the northeast Atlantic – keeping the sardines away from the coast.[6] When sardine stocks drop, the misery for fishermen and their families is not distributed evenly. As the area over which sardines are scattered shrinks, so many local fishermen are left without any catch at all. Fish-dependent towns and villages are plunged into poverty. In 1902 starvation loomed for tens of thousands of Bretons and a national call went out to raise funds for the beleaguered families. Archives of the Chamber of Commerce and Industry for Quimper, reveal:

The main sardine fishery in our region was nil in 1902; the fish had completely failed . . . [Local] families have been plunged into the utmost misery. Fortunately, the open subscription to help the Brêton fishermen exceeded all expectations and made it possible to relieve the main misfortunes.[7]

However, as year on year the sardines did not return, the generosity of the French government and the wider public began to wane. Between 1902 and 1907, many families in Brittany and Vendée moved inland as some 30,000 fishermen lost their jobs, along with at least 15,000 women who processed the fish. Taking into account the size of each family, and adding in welders,

The front page of *Le Petit Journal*, 1 February 1903, at the height of a French sardine crisis when many Breton fishing families were plunged into poverty.

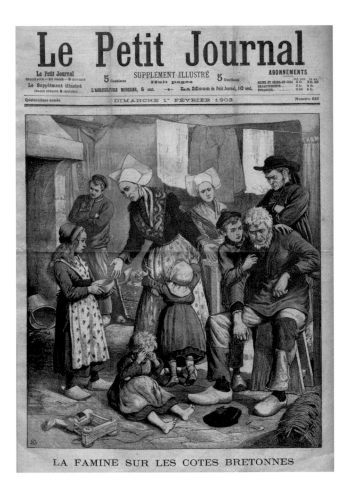

LA FAMINE SUR LES COTES BRETONNES

shipyard workers, netmakers and their families, about 100,000 people were catastrophically affected by the sardine shortage. Some displacements led to civil unrest, as when fishermen from Guilvinec moved south to Quiberon. Their fishing boats were attacked and damaged by local fishermen who feared the

sudden influx and threat to their livelihoods.[8] There were other displacements too, with many young women from Brittany leaving for Paris, where they took on work as maids, lace-makers and, in some cases, *filles de joie* in brothels.[9]

To overcome the inshore sardine shortage, massive investment and changes in technology could help the fishermen go further out to sea in larger vessels. A Finistère official reported in 1907: 'They must abandon their vessels and inadequate gear and engage in large-scale offshore fishing on bridged vessels.'[10]

The larger vessels did come, using seine nets rather than drift nets. And the sardine stocks – always variable – did re-establish themselves. But in the 1960s the European sardines abandoned both the inshore and offshore waters along the French Atlantic coast. It took until the early 1990s before they returned in strong numbers.

In the wake of disappearing sardines, displacement of human populations has become a regular feature elsewhere. In the late

Early 20th-century French sardine packers (*sardinières* or *penn sardines*) waiting for the fishing boats to return.

1960s and mid-1970s tens of thousands of seasonal workers became unemployed when the Namibian sardine industry crashed. Sardine canneries turned to canning fruit, fishermen changed to targeting first anchovies and then horse mackerel, and some fishermen and fish processors moved inland and returned to farming. After the sardine fishery began to build once again, low-oxygen events in the mid-1990s caused sardines to shift closer to the main fishing port, the ease of access resulting in intensive overfishing. The sardine population crashed once more. With environmental conditions deteriorating, the biomass of jellyfish came to exceed that of commercial fish. Jellyfish replaced the ecological niches that sardines and anchovies once occupied, and the jellyfish consumed juvenile fish, slowing down any fishery recovery.[11]

Fishermen – and sardine fishers are almost always men – swing between being extolled as heroes and cast as villains. When fish are abundant, fishermen are heroes and public interest focuses on the challenge of their job – long, antisocial hours in dangerous conditions to bring us hard-earned bounty. When fish become scarce, and overfishing is implicated, fishermen are demonized.

In 1968 Garrett Hardin, a professor of biology, wrote a classic paper, 'The Tragedy of the Commons', in the leading academic journal *Science*.[12] Hardin's thesis is that if many people have access to a shared resource – such as livestock grazing rights on common grassland – the inevitable consequence will be for individuals to graze their cattle as much as possible. If they do not, someone else will. Unchecked, this leads to inevitable destruction of the resource as it becomes overgrazed and deteriorates. To stop doing so requires moral restraint, or some agreed and enforced system of restraint.

If Hardin's ideas are applied to harvesting fish, fishermen left to their own devices will endeavour to catch as many fish as they can, to earn as much as they can, because those fish they leave

behind will be available to competing fishermen to catch and sell. The economic imperative is to catch fish quickly and efficiently, without regard for the long-term survival of the fish stock. As an individual, even if you wanted to hold back from over-exploiting the fish, there is no point in doing so unless all the other fishers agree. Unless there is some agreed and enforced system for holding fishermen back from over-exploiting the fish stock, the 'natural' tendency will be to do so. As a result, regional fish populations become economically non-viable and, in some cases, actually extinct.[13]

Fisheries science informing fisheries management is concerned with preventing this from happening and to ensure an equitable catch for fishermen while ensuring the long-term survival of an exploited fish population. For nearly a century, scientists have been diligently exploring ways of finding out what makes fish populations tick, and how we can better manage their harvesting. The basics are simple but matters rapidly become complex.

At its simplest, a discrete population of a particular sardine species, called a stock, is taken to be living in a particular region. If fishermen are to exploit the stock year after year, then there must be a balance between the biomass being added to the population (from reproduction, growth and possibly inward migration) and the total mortality (from fishing and other factors). If mortality exceeds renewal, then the biomass of the fish population will shrink, and fishermen will likely have fewer and/or smaller fish to catch.[14]

There are many complications. On the one hand, as soon as fishermen start catching appreciable amounts of fish, they alter the age structure of the fish population. They may selectively remove the larger fish – those that breed most successfully. On the other, when the population is thinned, each remaining fish may have access to more food and so grow faster and breed more

successfully. As we have seen, the success of young fish joining the fishery depends on the availability of the right food at the right time, which can be influenced by many environmental factors. Also, the populations of predators that feed on sardines – from egg to adult – may change in abundance from year to year. Clearly, even at this simple level, there are many factors at play.

'Classic' models for describing sardine and anchovy fishery responses to harvesting were based on an equilibrium view of a fish population. According to this, the numbers of fish might vary from year to year, but do so around an average (strictly, a mean, the most common type of average) based on the carrying capacity of the environment – the population it can support. Fisheries scientists, in working out the total catch from a fishery, usually adopted the maximum sustainable yield (MSY) approach – the largest catch that can be taken year on year without causing the population to collapse.[15] The MSY can be adjusted from year to year, taking into account changing circumstances.

To calculate the maximum sustainable yield using traditional models, fisheries biologists need to know the overall population size and age composition of the sardine stock, how swiftly the fish grow and reproduce, what they eat at different stages of their life cycle, and fish life expectancy. Added to this is the need to know the key environmental factors that influence growth, reproduction and mortality from year to year. Finally, how will the fish stock respond to a particular kind of fishing pressure – nets of a particular size and type, with a particular mesh size, used at a certain season of the year in specific locations?

Scientists then seek to convince politicians, administrators and the fishers themselves about what type and level of catch is sustainable, and how the fishery can be managed: the number and size of fishing vessels can be controlled, the timing and duration of the fishing season set, and the type of gear specified, including

mesh size (so allowing undersized fish to escape). A catch limit can be set for each boat and checks made so that undersized fish are not caught and sold. Policing is necessary to ensure that such practices are adhered to. It is such traditional practices that have been employed across the world for catching sardines. But the approach has been found wanting.

The French marine scientist Pierre Fréon and several of his colleagues have split the history of harvesting small pelagic fish, and attempts to manage them – among them pre-eminently, sardines and anchovies – into a number of historical periods.[16] The so-called 'mother nature period' (pre-1900) was the time when scientists and others regarded fish stocks as effectively inexhaustible – keep fishing and there will always be more fish to replace those you catch. Between 1900 and 1950, what Alec D. MacCall calls the 'developmental period',[17] there was a growing awareness, as intensive fishing developed and one exploited fish population after another crashed, that such inexhaustibility was clearly not the case. During this period, serious scientific studies got underway, including the use of Hardy's Continuous Plankton Recorder in the North Atlantic and the CalCOFI surveys off the Pacific coast of North America. Allied to this were glimmerings of wider awareness that natural environmental changes, not just human activities, affected the short- to medium-term success of a fishery.

Fréon and his colleagues' 'classical period', from roughly 1950 to 1975, saw the emergence of sophisticated mathematical models to describe how fish stocks were affected by exploitation and how, in theory, harvesting could be regulated to preserve the stocks. The collapse of sardine fisheries during this period – in California, France, Japan and Namibia – showed that either the models were not a 'good enough' analogue of the real world, or that the rec-ommendations from scientists were not being implemented. In

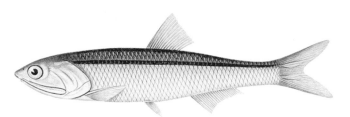

fact, both commonly applied. In any case, two events – two decades apart – were about to challenge the conventional equilibrium model of a fishery.

The first defining event was the catastrophic collapse of the Peruvian anchovy fishery in 1972–3. In 1970 this fishery was the largest in the world, accounting for some 13 million tonnes and about 18 per cent of the global fish catch. The fishing was highly regulated based on models developed by world-leading fishery scientists working in cooperation with the United Nations Food and Agriculture Organization (FAO). At the time the catch was nearing the calculated maximum sustainable yield.[18] In 1972–3 a strong El Niño event reduced the powerful upwelling close to the Peruvian coast. The anchovies stayed further south in deeper, cooler water, not only away from the fishermen but beyond vast populations of seabirds that would normally feed on them. The commercial anchovy catch dropped to less than 20 per cent of the peak, and hit rock bottom during the 1982–3 El Niño, at about 2 per cent. It was not until the mid-1990s that the fishery returned to large-scale catches. An El Niño event in 1997–8 brought another catastrophic crash, but recovery was quicker this time.

An El Niño is the planet's biggest, natural, short-term climatic shift, occurring every two to seven years. In most years, the mid-western Pacific Ocean is comparatively warm and the mid-eastern Pacific cool, chilled by the Humboldt Current arriving from the south. Trade winds drive from east to west, pushing warm surface

water away from the Peruvian coastline, and cool, nutrient-rich water wells up to take its place. The name El Niño (Spanish for 'male child') refers to the slackening of trade winds in December in 'normal' years, and is associated with Christmas and the Christ child.

In an El Niño year the trade winds slacken much sooner, so the strong Peruvian upwelling is weaker and less prolonged. Starved of nutrients, phytoplankton growth is poor, and the normal food web of zooplankton, grazing fish and their predators is disturbed. In a strong El Niño event, the effect on sealife is dramatic. During the 1982–3 El Niño, cormorants, pelicans and boobies starved, deprived of their normal prey. The unusually warm water in the eastern Pacific draws in other species of fish, including sardines, mackerel and horse mackerel along with the skipjack and yellow-fin tuna that feed on them, so that if the fishermen are adaptable, there are other quarry to hunt.

The second event prompting a challenge to the equilibrium model for a fished population was a report by researchers in southern California studying sardine scales preserved in undersea sediments. By examining sediments from the near-present to about 1,600 years ago, they discovered that the number of fish scales at a particular level in the sediment (and hence the number of sardines dying naturally at that time) varied substantially over timescales of a decade or so.[19] In other words, even without any fishing taking place, the numbers of sardines did not oscillate around an 'average' but varied substantially, with periods of abundance alternating with periods of scarcity. Something other than fishing – an environmental factor or combination of factors – was causing the local sardine population to increase or decrease.

El Niño events are short term. They occur against a background of longer-term climatic shifts lasting more than a decade. A regime change is a readjustment in the members of a marine

ecosystem, such that one fish species, formerly comparatively scarce, survives and grows better at various stages in its life cycle than another species. The shift from one fish to the other does not happen over a period of months, but rather over several years. Looking back at the catch records for sardines and anchovies over the last century, in a particular region there are periods of sardine abundance lasting a decade or more that sometimes alternate with periods of anchovy abundance. However, the pattern is not straightforward. The catastrophic collapse of the Californian sardine fishery in the 1950s is ascribed to a regime change – one that was unfavourable to sardines – coupled with overfishing. In the 1960s–80s, conditions were not favourable for sardines but were for anchovies. They improved for sardines from the mid-1990s, but currently conditions off California are poor for both fish.[20]

What underlies the conditions supporting one regime or another? Scientists suspect that it is the movement of bodies of water within the ocean, favouring the food supply and spawning success of one species over another. The problem lies in finding

Warm water in the eastern Pacific Ocean (represented by the dark region) is characteristic of an El Niño event at its peak. January 2016 ocean surface temperatures (right) compared to 1981–2010 average (left).

clear-cut physical, chemical and biological changes beneath the sea surface and associating them with the response of a particular fish population. The immensity and complexity of the ocean realm confounds us. Seawater is a huge, relatively inaccessible, three-dimensional space that is constantly moving, along with the organisms within it. Meanwhile, the sampling we do is very partial in space and time. We may be unable to reveal the subtle changes going on that mean success or failure for a generation of sardines.

Regime shifts form a background against any attempts to manage sardine or anchovy stocks. You need to know whether the prevailing conditions are favourable for the target fish species or not. Altering the maximum sustainable yield to take account of the prevailing ecosystem regime will help sustain the fish stock. At the moment, conditions are unfavourable for the Pacific sardine off California, and coupled with the 2014–15 El Niño this was sufficient to dramatically affect breeding, creating a twenty-year low in the sardine biomass.[21]

The last quarter of the twentieth century – and depending to whom you speak, it is still in progress – has been dubbed 'the doubt period'.[22] There is widespread recognition that conventional approaches to managing pelagic fish stocks, especially sardines and anchovies, have not been wholly successful. This has led scientists to incorporate three concepts – regime shift, the precautionary principle and ecosystem management – into shaping their forecasts and the management practices they recommend. Since 1995 we have been in the 'era of ecosystem management',[23] although it is in its early days, and some suggest it is optimistic to say that we have moved beyond 'doubt'.[24] Modern approaches are holistic, seeking to consider different dimensions of the fishing context; how the fish population responds, but also the wider human context – how the fishermen, the fish processors, consumers and international trade markets respond.[25]

The notion of the precautionary principle in its modern form originated in 1970s Europe.[26] If there is uncertainty about the effect an action will have on the health of the environment and its biological community, then the benefit of doubt should be given in favour of the environment. Lack of scientific certainty should not be a reason for holding back on making important decisions. This is the problem that dogged Californian scientists from the 1920s to the 1950s, trying to get politicians, entrepreneurs and fishermen to refrain from overfishing sardines. It is also the problem that has delayed – and still delays – decisions about combating global climate change. The data are never good enough. Decisions will always need to be made in the face of uncertainty. Like it or not, these are always judgement calls. But inaction can result in irreversible environmental changes, or changes that may take many decades to resolve, as in the case of curbing greenhouse gas emissions and seeking to stabilize human-caused global warming.

Ecosystem management of a fishery goes beyond management of a single fish stock, but more strongly considers the regional ecosystem as a whole – the food of sardines, the predators of sardines and the potential competitors of sardines (such as anchovies, herring, sprats and so on). It considers how these different players are being impacted by physical, chemical and biological factors. In managing so-called 'small pelagic fish stocks', and especially sardines and anchovies, short-term variations need to be taken into account, as well as the longer-term ones – such as regime changes.[27] At the moment, implementing these ideas is still in its infancy.

The fishery for the Pacific sardine off the west coast of the United States, Mexico and Canada utilizes the world's most sophisticated physical, chemical and biological sampling techniques and mathematical modelling approaches. The fishery is

assessed and managed through a model called ss (Stock Synthesis) that uses data from many sources.[28] Fish are sampled from catches landed in ports and examined for individual weight (kg), standard length (cm), sex and maturity. Some otoliths are removed for ring counts to determine the age of the fish. Sampling surveys using nets allow scientists to estimate egg production and the biomass of spawning fish. Echosounding combined with trawling enables scientists to work out the biomass of shoals they see on sonar screens. They can then assess the biomass of further shoals using echosounding images alone.

According to the ss model, fishing is not permitted if the total biomass of the stock is below 150,000 tonnes. The biomass for July 2017 was projected to be about 86,000 tonnes,[29] and the u.s. sardine fishery was closed for the third season in a row.[30] The management system seemed to be working – insofar as the fishermen responded as requested – but it was the sardine stock that was not responding. Where does that leave us now?

Undoubtedly, moving towards an ecosystem approach for fisheries management is progress in the right direction. Even without implementing a highly developed ecosystem approach, South African, North African and some European stocks of sardines have been managed reasonably effectively in the last two decades, and catches have been sustained. But as the Californian experience shows us, generating computer models is one thing, pinning down the complexities of what is actually happening beneath the ocean is quite another. We have yet to come close to really understanding the sardine's world.

# 6  Cultural Sardines

For two days each year, the oldest quarter of Lisbon, Portugal, the Alfama, pulses to the music of brass bands and the air fills with the savoury aroma of grilled sardines. Impromptu charcoal grills appear in the back streets, with whole, grilled sardines served in simple style with rock salt, boiled potatoes and green salad.

In Lisbon 12–13 June marks the Feast of St Anthony of Padua. The accompanying festival celebrates a thirteenth-century Catholic monk from Portugal who allegedly preached to attentive fishes in Rimini, Italy – one of St Anthony's many miraculous deeds. Mid June in Portugal is soon after the start of the traditional sardine fishing season, when the fish are plump and well conditioned. Unsurprisingly, this abundant, tasty fish has become associated with the festival and St Anthony's miracles. A twentieth-century translation of the fourteenth-century *Little Flowers of St Francis* relates what happened when the people of Rimini would not listen to the monk:

> Wherefore St Antony gat himself one day by Divine inspiration to the bank of the river hard by the sea, and standing thus upon the shore between the sea and the river he began to speak unto the fishes, as a preacher sent unto them of God: 'Hear the word of God, ye fishes of the sea and of the river, since the infidel heretics refuse to hear it.' And anon,

St Anthony preaching to the fishes, as depicted in Arnold Böcklin's 1892 oil painting of *St Anthony*.

With wise management, sardines are a sustainable fish in the longer term even if there are short-term shortages. Here sardines are placed next to sea bass – their predators – on a fish stall in Lisbon, Portugal.

> when he had thus spoken, there came to him to the bank so vast a multitude of fishes, big, little and of middling size, that never in that sea or in that river had there been seen so great a multitude. And all of them held their heads out of the water, and all gazed attentively on the face of St Antony.[1]

The fish bowed their heads in reverence. Upon witnessing the miracle, the previously intransigent local disbelievers apparently converted to Catholicism.

At Lisbon's Festival of St Anthony, his power as a miracle worker has extended to all manner of things, with romance and fertility high on the list. Men post love poems in basil plants. Single women bury statues of St Anthony upside-down, threatening not to uncover them and turn them right-way up until they have found a potential husband. Some place rolled-up papers with the names of potential suitors in bowls of water under their beds, waiting until morning to discover which has unfurled the most to reveal the lucky man.

In Spain and some of its former colonies, sardines are associated with festivities in late winter or early spring in preparation for the Christian period of Lent. After three days of carnival celebrations, a parody of a funeral parade assembles on Ash Wednesday, the day before Lent begins. The procession is more like a Mardi Gras extravaganza, with music and dancing but with celebrants dressed in black as befits mourners. A real or symbolic sardine is carried to its resting place, where it is buried or burnt to represent the purging of vices. There is much extravagant wailing from men dressed as widows in period costume. In modern Madrid, the procession through the old quarter, the Castizo, is led by the 'Brotherhood of the Sardine' – normally reputable gentlemen who dance, sing and carouse their way alongside the coffin, which contains a sculpted sardine.

Grilled sardines are the favoured food at St Anthony's Feast in Lisbon, Portugal.

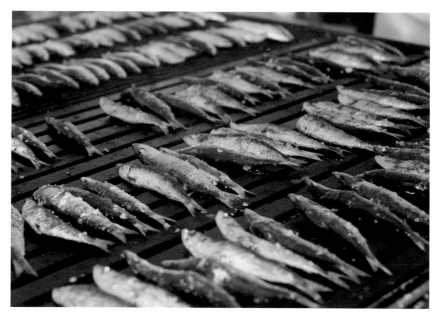

The Burial of the Sardine represents the putting away of earthly pleasures before the forty days of abstinence and fasting leading to Easter, marking the death of Christ, his ascension and a period of renewal. The origins of the burial practice are obscure. One of the more convincing explanations asserts that in the eighteenth century a delivery of rancid sardines arrived in Madrid and drunken revellers thought that burying the stinking fish was a fitting way to end the carnival celebrations. The burial became a tradition.

The Spanish painter Francisco Goya's oil on panel *The Burial of the Sardine* depicts the final day of the three-day Madrid carnival. The painting is regarded as a masterpiece, marking a period of transition from Goya's early tapestry cartoons of celebratory public events and his later sombre Black paintings, brooding on insanity and mortality. In the painting's details of revellers, gaiety mixes with signs of hysteria and faces of death.[2]

Christianity is rampant with fish symbolism. In Graeco-Roman times, believers were called *pisciculi* (little fishes). The church font in which babies were baptized was the *piscine* – literally, a fish-pond. The Greek word for fish, ἰχθύς (*ichthys*), is an acronym for Jesus/Christ/of God/the Son/Saviour. The symbol of a fish came to represent Christ himself, and the mark of a fish was placed on objects accompanying burials.[3]

In the King James' version of the Bible, Peter the apostle, a fisherman of Galilee, and his brother Andrew became 'fishers of men' (Matthew 4:19). In Peter's fishing boat, Christ performs the 'miraculous draught of fishes', with the net so laden that Peter must enlist the help of James and John in a neighbouring boat to bring in the fish (Luke 5:1–11). Christ reassures Peter with, 'Fear not; from henceforth thou shalt catch men' (Luke 5:10). In the 'feeding of the five thousand' (John 6:1–13) it is the two staples – bread and fish – that are multiplied to feed the assembled multitude. It is no

On Ash Wednesday, The Burial of the Sardine carnival marks the end of the festival season and the beginning of Lent, as here in Madrid, Spain.

wonder that fish feature strongly in some Christian ceremonies and when sardines are on hand, these slivers of silver are as good a symbolic fish as any other.

In other spiritual traditions, and in secular worlds, fish are variously associated with fertility, sexuality (both male and female) and birth and rebirth. Female fish of many species produce copious quantities of eggs – hundreds or thousands. Based on their shape, elongated fish can be perceived as phallic, or with the tail fin removed, a fish's diamond-shape is seen as resembling a woman's vulva – a remarkable feat of imagination![4] In cultures where catastrophic floods feature, fish are among the few survivors, and so are bestowed with the qualities of survival and freedom. Catfish can survive submerged in mud, emerging when the rains return – lending further credence to the regenerative properties of fish.

A rock-carved sculpture of a salmon (c. 23,000 BCE) in Abri du Poisson cave in the Dordogne, France, is among the first artistic representations of a fish. Other than more or less realistic depictions, early fish art often expresses symbolically the qualities of the Great Goddess or Earth Mother, the female embodiment of Earth's life force – nurturing, fertile, regenerative.[5] Fish are associated with life-giving water and are, of course, a staple and nutritious food.

In Egypt, by 2,000 BCE, recognizable fish such as tilapia were being painted on the walls of tombs, and later on drinking bowls and papyri. The fish-goddess of Lower Egypt, Hatmehit, is crowned with a fish.[6] Across the world, where fish are depicted in artwork or ceremonials, they often represent iconic species with special qualities, such as the heroic return of the salmon to the spawning grounds where it began life, or the fighting qualities of sharks.[7] In medieval Chinese symbolism, the word for fish (yu) is a homonym for the word representing abundance or plenty. In Chinese

Francisco Goya's *The Burial of the Sardine*, 1810s, oil on canvas, combines gaiety with hysteria and portents of death.

traditions, fish have come to represent wealth, marriage, fertility and felicity.[8]

In a provocative article, 'Cultural Symbolism of Fish and the Psychotropic Properties of Omega-3 Fatty Acids',[9] two researchers proposed that the association of fish with the qualities of purity and health may be due to the physiological and psychological effects of omega-3 fatty acids. These chemicals, abundant in oily-fleshed fish such as sardines, when consumed and absorbed, have beneficial effects on the cardiovascular system. However, they also claimed that the chemicals have neurological and psychological influences, moderating aggressive and impulsive behaviour.[10] They argued that the health and well-being benefits of eating fish, including the effects of omega-3 fatty acids, are reflected in the recommended practices and symbolism of spiritual traditions, from Judaism and Christianity to Islam, Hinduism, Buddhism and Shinto. While recent Cochrane medical reviews support the cardiovascular benefits of omega-3s, they no longer support claims of significant psychological or behavioural benefits.[11]

By the European Renaissance, and especially among the Dutch painters, fish symbolism had both pagan and Christian attributes. On the one hand, a fish is a phallic symbol and represents folly and licentious revelry in men and lack of chastity in women.[12] On the other, fish are a staple food during Lent and when symbolic of Christ, imply resurrection and rebirth. These contrary interpretations are found in the works of Hieronymus Bosch (c. 1450–1516). In the left panel of Bosch's Lisbon Triptych on the *Temptation of St Anthony*, flying fish are phallic symbols symbolizing an erotic aspect of Anthony's temptation.[13] In the middle panel of the Millennium Triptych a walking fish is seen as symbolic of Christ and the Resurrection.[14]

In Brittany, France, formerly a strongly Catholic region, the sardine's importance has risen well beyond the economic to

infuse the coastal region with a sardine culture. Many Breton towns and villages had traditions associated with sardines. In Saint-Gilles-Croix-de-Vie a boat-owner kissed the first sardine of the season to be caught on his vessel. On 24 June, at what used to be the height of the sardine season, a sardine Mass would be celebrated in Notre-Dame de Larmor-Plage in Morbihan. In September many communities celebrated the end of the main sardine season. Sardines, fishermen, sardine factory workers and their apparel have become the focus of many popular Breton songs – among them 'La Sardinière' (The Sardine), 'Les Petits Sabots' (Small Clogs) and 'Pour Les Filets Bleus' (For the Blue Nets). The nets of early twentieth-century sardine fishermen were dyed blue. In Concarneau in August each year, the Les Filets Bleus festival celebrates local culture, with parades in traditional costume and much playing of Breton bagpipes. The annual festival began in 1905 to raise money for impoverished sardine fishing families.[15]

Some of France's most politically active women came from the ranks of the sardine processors in the Douarnenez region of Brittany. Called *penn sardines* (literally 'sardine heads'), their name is credited to the traditional white lace or linen bonnet that protected their hair when working. The name is also ascribed to the way the women were paid on a piece rate according to the number of sardine heads they cut off when processing the fish.[16]

In 1905, after several years of sardine shortages, female Breton sardine packers were still being paid by the number of sardine heads they removed – from 1.50 to 1.75 francs per thousand fish processed. At this rate, they earned about 1 franc a day (one-quarter or less than skilled male workers employed locally). The women went on strike in protest at the low pay, piece rates and poor working conditions. The canning factory owners eventually relented, and agreed to hourly wages and other concessions.[17]

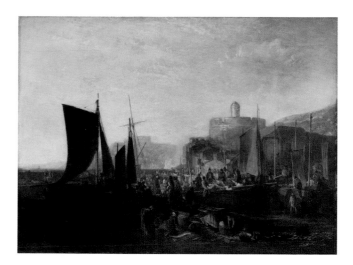

This romantic Neoclassical image of *St Mawes at the Pilchard Season*, 1812, by J.M.W. Turner belies the Cornish fishing industry being depressed at the time as England was engaged in war with France.

By 1924 there was a new set of grievances, as the Douarnenez cannery owners were now breaking national guidelines about women working at night and how many hours they could work continuously. Women would also wait many hours for the sardine boats to arrive – hours during which they were not paid. The *penn sardin* strike dragged on amid acrimony and physical violence. Strike-breakers were brought in to disrupt the women's solidarity. Nevertheless, the strike remained solid for 46 days, after which the women won many concessions – better wages, improved working hours and agreements on overtime and night work. The *penn sardin* strike became a landmark success for French trade unionism.[18]

Sardine fishing and sardine processing is hard, dirty work, but French painters of the nineteenth century gave them a romantic allure. Impressionists and neo-Impressionists tended not to paint sardines themselves, but the fishers and especially their boats, as in Paul Signac's *Evening Calm, Concarneau, Opus 220*

Paul Signac's 1891 *Evening Calm, Concarneau, Opus 220 (Allegro Maestoso)* shows sardine and other fishing boats. Part of his symphonic sequence of five paintings, supposedly inspired by the rhythmic movement of boats on the wave.

Carl Moser's 1926 hand-coloured woodcut *Strickende Bretonin*, depicting a *sardinière* watching the sardine boats come in.

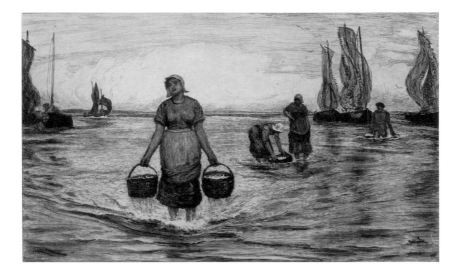

This etching, *Landing Sardines at Low Water*, by the Scottish artist Robert Walker Macbeth (1848–1910), combines Romantic and social realist elements. It shows the labour-intensive nature of the 19th-century British sardine industry.

*(Allegro Maestoso)* (1891). The musical reference is to the graceful tempo of the waves, gently rocking the fleet of sardine boats. A hand-coloured woodcut from 1926, *Knitting Breton Woman*, by the Austrian artist Carl Moser depicts a *penn sardin* knitting as she waits for the sardine boats to return. This idealized scene is a far cry from the political fervour of 1924 and the reality of the working lives of fishers and fish packers.

In nineteenth-century Europe sardines and sardine fishers were also being depicted in Neoclassical style, as in J.M.W. Turner's *St Mawes at the Pilchard Season* (1812), or with heightened realism by Percy Robert Craft in his *Tucking a School of Pilchards* (1897) and in his line drawings for books documenting the Cornish fishing industry.

Sardines are popular subjects in modern art, most often depicted in cans, on a fishmonger's display or on a plate, as in Ben Rikken's *Sardines on a White Plate* (2014). In contemporary nature

art sardines swim free in the ocean, as in the 2014 British postage stamp showing Cornish sardines as part of a sustainable fish series.

What is it about sardines that appeals to artists? They are archetypal fish – whether in their natural environment, or not, they are clearly defined, sleek, silvery. En masse, they represent faintly tragicomic human qualities – diminutive, crushed together, sometimes panicking.

A subgenre of art has grown up around, and now inside, the confines of a sardine can. The brightly coloured, decorated face of the can has always been the miniature billboard on which to advertise the juicy contents.

The discarded empty sardine tin, in itself, can be a canvas and frame or plinth and sculpture. The can encloses a miniature realm, which in our recycled, closely packed world becomes a space for artistic expression. Sculptor and artist Nathalie Alony in her whimsical series *Home Sweet Home* has created humorous dioramas of everyday life inside 10 cm × 6 cm sardine cans. Each depicts a different room in a different household with a domestic vignette of characters modelled in clay – adults bathing young children, playing

British stamp from 2014 showing Cornish sardines in the *Sustainable Fish* series from the Royal Mail.

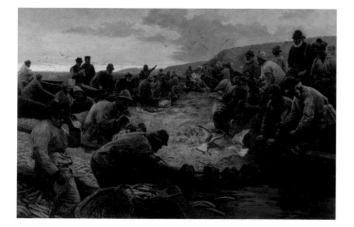

Percy Robert Craft's 1897 oil painting *Tucking a School of Pilchards (The Tuck Boat)* is an idealized but otherwise accurate depiction of Cornish fishermen using a tuck net to extract pilchards from a seine net.

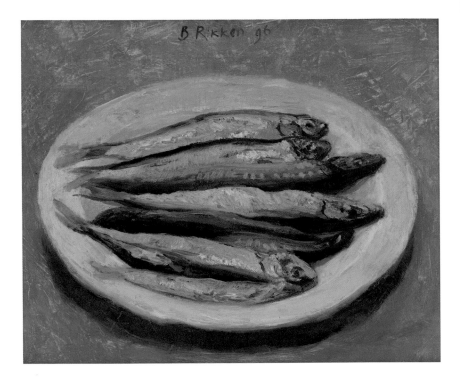

Archetypal fish:
Ben Rikken's
*Sardines on
a White Plate,*
2014, oil painting.

cards, watching television, making love. As Alony explains, 'All these different lives, different stories, different histories and futures, all that intimacy, condensed between four walls . . . in little apartments, "little boxes", that each of us call HOME.'[19]

For award-winning Australian artist and sculptor Fiona Hall, the sardine can is a vessel that brings together plant and human motifs – exemplifying the relationship between the plant world and humankind. In her *Paradisus Terrestris* series, a plant in metal grows out of a peeled open can, revealing a metal-sculpted human body part.[20] The 'paradise on Earth' is the genetic diversity of the natural world, which is threatened by human actions.

In literature, as in public perception, the sardine is associated with abundance, conformity, powerlessness and constraint. In British author Sid Chaplin's coming-of-age novel *The Day of the Sardine*, published in 1961, the protagonist Arthur Haggerston leaves school with few prospects.[21] His father is absent and his mother, Peg, protective. They live in a slum-clearance area of Newcastle upon Tyne, northern England, and share the house with Harry, a former seafarer and trawlerman, who is Peg's lodger and sometime lover. Harry's philosophical outlook is unusual coming from someone who now works in a sardine cannery.

Sid Chaplin is one of several 'angry young men', British social realist novelists from the 1950s and '60s, among them Stan Barstow, John Braine and Alan Sillitoe. Although critically acclaimed, Chaplin's work is less well known than that of the others, with Chaplin's characters speaking in Newcastle (Geordie) dialect and some literary critics downplaying his works as 'regional novels'.[22]

*Limits of Intimacy,* one of NaTalica's (Nathalie Alony's) dioramas in a sardine can.

145

In *The Day of the Sardine*, after sharing his observations about fishing for sardines, Harry the lodger advises thirteen-year-old Arthur:

> 'All they know is the shoal,' he said. 'All they care about is to eat at eating time and spawn at spawning time. So into the net they run and end up in a little tin box.'

The sardine is an iconic image in fish-loving Lisbon, Portugal.

'What a come-down for you!' I said. 'Ah'd rather fish for 'em than work in a packin' factory.'

'You miss the point.'

'What's that?'

'Don't be a sardine. Navigate yourself.'

'Ah'm goin' to be Somebody.'

'And what's that?'

'Get filthy rich, hob with the nobs, drive a Jaguar, have a private swimmin' pool.'

'Another kind of sardine – plush-lined tin, that's all.'

'Better than bein' a sardine slave, anyway.'

'Thought you'd say that. But you're wrong. Ah use the sardine factory the way Ah used the sardine boats: to eat to live and not living to eat. You think Ah'm with the shoal – eh? But that's not the case. Ah'm swimmin' on me own.'[23]

In his late teens, Arthur is torn between conforming with the violent, macho culture of his local gang, an affair with a woman whose husband is at sea and a pastor's daughter he idolizes, all the while failing to come to terms with his father's absence and his mother's deepening relationship with the lodger. Against Newcastle's gritty backcloth, a city with a shipbuilding industry in decline, Arthur takes on one menial job after another and experiences several escapades – part comical, part tragic – including gang fights, temporarily burying corrupt employers in an underground sewage pipe, witnessing the aftermath of a murder and going on the run. Arthur meets his bigamist father and makes peace with Harry and his mother, who eventually marry. When the novel ends, Arthur is working in the sardine cannery, striving to make sense of his place in the world and whether he will be a grudging conformist – a sardine – or something else.

*The Shark and the Sardines*, written by the former president of Guatemala Juan José Arévalo and published in 1956 in Spanish, is on a much larger stage.[24] The shark is the United States and the sardines are the Latin American countries that it consumes – or, according to Arévalo, exploits, destabilizes and bends to its will. The story of the United Fruit Company (UFC), founded by two U.S. businessmen in 1899, is one of controlling a product's entire supply chain and creating a monopoly. With the collusion of the Guatemalan and U.S. governments, the UFC came to own plantations, employ workers and run railways, ports and shipping, which brought bananas from the 'banana republic' of Guatemala to the United States and the rest of the world.[25]

In flamboyant style, *The Shark and the Sardines* charts the ebb and flow of Guatemala's troubled twentieth-century history, an allegory for the political fluctuations of a small country struggling to establish democracy and greater equality for its citizens. In 1944, after decades of right-wing dictatorship, Juan José Arévalo was elected president and in subsequent years brought in educational reform while seeking to strengthen workers' rights and loosen the dominant landowners' stranglehold on farming.

In 1950 Jacobo Arbenz, a socialist, took over as the democratically elected president. By 1952 new laws had the government buying up unused land from the UFC and other large landowners and distributing it to workers. In the longer term Arbenz planned to nationalize the country's railway system and ports, and in the shorter term the government started funding new rail and port infrastructure. Since this was a clear threat to the UFC's interests, the U.S. government branded Arbenz a communist and, through the CIA and mercenaries, arranged a *coup d'état*. In 1954 Arbenz was replaced by Castillo Armas, who was much more amenable to UFC and U.S. interests. The machinations of the U.S. government and the UFC in Guatemala, and elsewhere in Latin America, have

been largely confirmed by later scholarly publications.[26] In Latin America, the socio-political meaning of shark and sardine is a widely familiar one.

By the late nineteenth century, when sardines in tins had become common fare – laid first one way and then the other to exploit the full volume of the can – 'packed together like sardines' had become a familiar expression across many languages. In twentieth-century Tokyo and New York the railway or subway employees who pushed passengers together to cram them into carriages were called sardine packers.

At this expression's most chilling, 'sardine packing' (*Sardinenpackung*)[27] and 'the sardine method' (*Ölsardinenmanier*)[28] were the deplorable terms used by Nazi death squads as they shot Jews and stacked them one on top of the other, head to toe, in mass graves. By closely packing the bodies like sardines in a can the maximum

The Tokyo rail system is one of the world's most efficient but also most crowded. Guards, sometimes called 'sardine packers', push commuters into the carriage so that the doors can be shut.

number could fill graves. 'Sardine packing' – the method and the phrase – is ascribed to ss Commander Friedrich Jeckeln. He oversaw the Rumbula massacre in Latvia in 1941 when about 25,000 Jews from the Riga ghetto were murdered and buried in this manner.

In children's literature the writer Emmanuel Guibert and artists Joann Sfar and Mathieu Sapinare are the co-creators of ten graphic novels – and counting – in the *Sardine in Outer Space* series, originally published in French (*Sardine de l'espace*) and aimed at a seven- to nine-year-old readership. Sardine is the red-haired swashbuckling niece of galactic pirate Captain Yellow Shoulder. In the first English-translated book in the series, they voyage in a fig-shaped spaceship, *Huckleberry*, battling the pencil-moustached villain Supermuscleman, who, with his sidekick, the brainy, lizard-like Dok Krok, runs a puritanical space orphanage.[29] Drawn in an attenuated *Beavis and Butt-head* style, the slicing and filleting of enemies, plentiful slime and gloopy presence of unpleasant body fluids, together with slapstick humour and cultural references, make it entertaining reading for boys and girls of many ages. Sardine is invariably the heroine that saves the day.

In Stephen Knight's award-winning collection for young adults, *Sardines and Other Poems*, the book's eponymous poem is about the game sardines, a version of hide-and-seek in which everyone stays together, hidden, when found by others, until only one person is left as the seeker. In the poem a person hides in a wardrobe waiting thirteen years to be discovered – perhaps an allegory for hiding his heart from the world.[30]

The 2009 animated film *Cloudy with a Chance of Meatballs*, based on Judi and Ron Barrett's book of the same name, is placed in Swallow Falls, a fictional island in the Atlantic Ocean off the u.s. East Coast famed only for its sardines. When this food falls out of favour worldwide – the newspaper headlines read

'Sardines are super gross' – the island's sardine canning factory is destined to close. The film's hero, Flint Lockwood, is the nerdy son of the owner of the increasingly dilapidated Sardine Bait and Tackle Shop. In this fanciful incarnation, sardines are caught on rod and line as well as being bait for larger fish. Flint's inventive genius backfires when his latest gadget destroys the amusement park 'Sardine Land' on its opening day. That same gadget creates food-forming clouds that initially are a saviour to Swallow Falls's economy, but rapidly become a worldwide threat, unleashing hurricanes and threatening to inundate the globe with downpours of food. Ultimately, Flint triumphs and saves the world, but the sardines remain objects of ridicule or pity in this visual feast of a film.

In the real world sardines have even become a symbol of protest. Since the early 1930s a Chisso Corporation chemical factory had been discharging noxious chemicals into Minamata Bay, Japan. By the 1950s, local birds, cats and then people were showing disturbing neurological and musculoskeletal signs, in many cases leading to death. Despite plentiful evidence by the late 1950s that the Chisso factory's discharge was the cause – methyl mercury was being concentrated through the food web, and reaching high levels in fish, which were then being consumed – it was not until 1968 that the Japanese government forced Chisso to stop discharging contaminated water. Ultimately, more than nine hundred people were to die from the contamination and many thousands left permanently disabled.[31] By early 1973 the Chisso Corporation finally agreed to pay compensation to some Minamata victims, but not to the fishermen whose livelihoods had been devastated. In protest, in July 1973 Japanese fishermen dumped 5 tonnes of sardines outside the gates of the Minamata factory.[32] Fish, once a potent symbol for good health and nutrition in Japan, had come to be linked with toxicity and death.

Today Minamata disease remains a medical term for chronic mercury poisoning and its effects.

In 1937 a decade before Aldo Leopold's (1949) lyrical account of our relationship with the natural environment – *Sand County Almanac and Sketches Here and There* – an American poet was drawing parallels between the human condition and its relationship with technology, and humanity's effect on the natural world. Robinson Jeffers, in 'The Purse-seine', potently reveals the catching of sardines off Monterey as a metaphor for the constraining, ultimately fatal, effect of technology on our lives:

> I cannot tell you
> How beautiful the scene is, and a little terrible, then, when
> the crowded fish
> Know they are caught . . .[33]

Jeffers likens the enfolding mesh of the net to the constraining effect of technology on human life, robbing us of our ability to survive without it, and severing our connection with the natural world.

At another extreme, in the poem 'Sardines' by British comic writer Spike Milligan, the relationship between people and sardines is subverted. A sardine mother and her baby swim past a submarine, with the mother commenting, 'It's only a tin full of people.'[34]

The lyrics of The Beatles' song 'I am the Walrus' include references to semolina pilchard. According to Marianne Faithfull, former girlfriend of Rolling Stones singer Mick Jagger, this refers to Detective Sergeant Norman 'Nobby' Pilcher, who arrested John Lennon for drug possession in October 1968. Pilcher had built his reputation targeting pop stars with several high-profile drug busts. As Lennon claimed, saying Pilcher had framed him

on this occasion: 'He went round and bust every pop star he could get his hands on, and he got famous. Some of the pop stars had dope in their house and some of them didn't.'[35] In 1973 Pilcher was convicted and imprisoned on a charge of conspiracy to pervert the course of justice after it was suspected that he planted evidence in several drug convictions. Lennon never did confirm the true meaning of the 'I am the Walrus' lyrics.

A diminutive art gallery in Brooklyn, New York, is called Sardine. Small and packed with food for the mind, Sardine is the latest in a long line of cultural references to sardines. From religious symbolism through political allegory to children's fiction, sardines have embedded themselves in our collective consciousness, sometimes comic, sometimes tragic, often underappreciated.

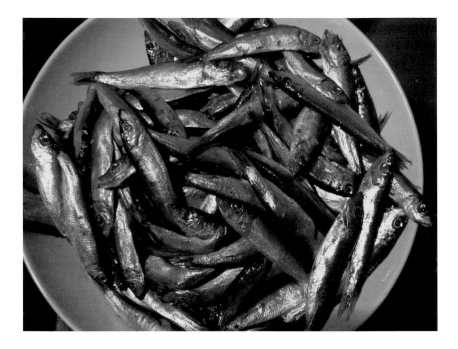

# 7 Prospect

One recent August, a friend and I were snorkelling in a remote bay in southwest England. Floating, barely moving, I happened across a school of baitfish – that year's sprats, a relative of sardines – at 5–7 cm long, swimming steadfastly, mouths agape, filtering the water for plankton food. The school took more than ten minutes to pass me by. I must have been watching tens of thousands of fish.

At the end of the afternoon, we were walking back when parts of the bay erupted in what seemed to be localized rainstorms. We would hear the pitter-patter before seeing the patch. A look upward showed no storm clouds. This was not rain: it was fish. Baitfish were scattering across the sea surface, attacked from below by some unseen hunter. This was happening right across the bay – two, three, sometimes five patches – the biggest some 10 m across and several times that length. This was the tens of thousands of baitfish I'd seen earlier. I raised my estimate to hundreds of thousands.

What was attacking them? I'd speculated sea bass, having seen them doing so two seasons before, but two local anglers, father and son, put me straight, 'Nah, this is mackerel madness.' This late August event barely makes a mention in social media or the local press. Close to shore, marauding mackerel attack shoals of baitfish and the sea surface becomes a battleground. To underline the claim, the son cast his multi-lure rig alongside one of the patches and hauled in two trembling, belligerent mackerel.

Whitebait are the young – typically about 4–6 cm long – of clupeid species such as sprat and sardine.

By now, the mackerel were driving two of the patches towards the shore. On cue, a wave of baitfish arced above the water and crashed on the sand and shingle – a quicksilver, quivering strandline.

A family walking their dog at the water's edge had been oblivious to the wild action beyond. But they could not avoid the thousands of fish being dumped at their feet. Dog and family looked perplexed, then the family started scooping up handfuls of fish, throwing them into the water, seeking to save as many as they could.

Higher up the beach, the few families who had taken the trouble to reach this remote cove continued basking in the late afternoon sun, playing catch and listening to who knows what

Visitors on a beach may have little awareness of the drama being played out in the ocean beyond, as here in St Ives, Cornwall.

through their headphones. They were unaware of the natural spectacle being played out a few metres away. All that was needed now, to complete the set, was a chef gathering the whitebait for his restaurant and a fish-hater stamping fish into the sand.

Sprats are not sardines, but they are closely related, and the spectacle we witnessed could just as easily have applied to sardines. The experience served to remind me of the range of people's reactions to any natural phenomenon. But I couldn't help noticing how unaware so many of the onlookers appeared to be. Added to this, our relationship with any life form is multifaceted and our understanding partial – especially when the animal lives in such a vast and mysterious expanse as the ocean.

Sardines grow and breed quickly. If conditions are right, a sardine population can expand rapidly. On the other hand, if conditions are not right, the population can collapse quickly too – within five years or less. This rapid response makes sardines a good barometer for how environmental conditions – sea temperature, shifting water masses, pollution, plankton abundance and so on – are changing.

Despite the capacity of sardines to form local populations of billions of fish, geneticists analysing their DNA have revealed that both *Sardina* and *Sardinops* have undergone 'genetic bottlenecks' – times in their long history when their vast populations shrank to a fraction of their former size.[1] Expansions and contractions in population size have not just happened over timescales of millions of years but, as we have seen, over a few decades. Even without human actions complicating the situation, through overfishing or pollution, sardine populations expand and contract with changing environmental conditions.[2]

Today, our attempts to manage the oceans and its harvest may well be thwarted by our most pervasive effect on the environment – rising carbon dioxide levels in the atmosphere. The

impacts of this single factor include climate change, rising seawater temperatures and increasing seawater acidity, which in turn have myriad effects on ocean creatures. To take just one example, there is a connection between climate change, overfishing, sardines and the stench of bad-egg gas (hydrogen sulphide) in California. It needs some disentangling.

Global warming, now called by preference climate change because of its widespread and tricky-to-predict effects on weather and climate, has in the last thirty years moved from scientific speculation to scientific fact. Thousands of interdisciplinary studies reviewed by dozens of international teams, under the aegis of the Intergovernmental Panel on Climate Change (IPCC), have come to estimate that the Earth's average surface temperature will increase by at least $1^{\circ}$C, and probably significantly more, between 2005 and 2100.[3] The main culprit is human-caused (anthropogenic) rises in greenhouse gas levels in the atmosphere.

Greenhouse gases – notably, carbon dioxide, methane and water – have kept Earth's surface at equitable temperatures for many millennia. However, human population rise coupled with industrialization and changes in land use have dramatically raised atmospheric greenhouse gas levels. Carbon dioxide is released in copious amounts from the burning of fossil fuels for heating and transport, and from the removal of forests and other changes in land use. Added to this is the escape of methane from rice paddy fields, gaseous emissions from livestock, combustion of biofuels and the decomposition of organic matter in landfills. Between pre-industrial times (taken as 1750 CE) and 2015, levels of atmospheric carbon dioxide rose by some 42 per cent.[4] In that time, atmospheric methane levels have more than doubled. The rising levels of greenhouse gases are warming Earth's atmosphere. The IPCC's projected global average temperature rise for the twenty-first century is in the range $1.0^{\circ}$C to $4.1^{\circ}$C based on

various scenarios. The range recognizes that what we do to curb greenhouse gas emissions will dramatically affect the outcome.[5] A temperature rise of 4°c may seem hardly of great concern – longer growing seasons perhaps and milder winters. The consequences are, in fact, much more profound. One effect is to shift ocean currents.

Ocean currents move across oceans, but they also rise and fall. In some places, surface seawater sinks to the depths. One such location is in the extreme North Atlantic. Here, the chilling of seawater alongside the Arctic ice sheet, and the freezing of seawater that liberates salt, cause seawater to become denser and sink. To compensate, there must be places elsewhere where seawater rises to the surface. Some of these places are on the eastern boundaries of oceans, where winds drag surface water offshore, leaving space for deep, cold, nutrient-rich waters to rise to the surface. These and other upwellings occupy only about 1 per cent of the ocean's surface, but they are the source of about half the world's fish catch. It is at eastern boundary upwellings where fishermen catch most of their sardines and anchovies.

In the near-shore waters off the parched Namibian coastline lies one of the planet's most vital upwellings. Such is its intensity that it produces problematic effects. The growth of phytoplankton is so rapid, and the offshore current so intense, that the zooplankton that graze on plant plankton cannot keep pace. They tend to be swept away from the upwelling before they can efficiently harvest the phytoplankton. However, there are fish that can crop the phytoplankton – sardines and anchovies. But with the economic demise of these fish through overfishing, they are no longer present to pick up the slack. Unharvested phytoplankton sink to the bottom of the sea, decompose and create a stinking, oxygen-free environment rich in hydrogen sulphide and methane. Little can survive here save for relatives of the bacteria that were

Hydrogen sulphide eruptions shown as pale regions along the coast of Namibia, as here in March 2012, are the result of a complex chain of events. The noxious gas kills fish, including sardines.

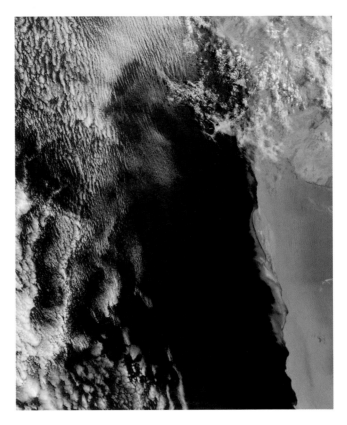

present on Earth more than 2 billion years ago – when Earth's atmosphere lacked oxygen.

Worse still, some methane and sulphur dioxide rises to the sea surface. Even when sardines or anchovies were plentiful, 'sulphide eruptions' bubbling at the sea surface caused the stench of bad eggs to waft over nearby ports, stinging the eyes and irritating the throats of locals. With the loss of sardines and anchovies, these eruptions have become more intense and more frequent, creating

intense sulphide fogs that regularly beleaguer the people living along the Namibian coastline.[6]

Something similar could happen in northern California, around Monterey. University of Miami scientist Andrew Bakun predicted that climate change will intensify the winds that give rise to coastal upwellings.[7] If northern California's offshore currents are strong enough, sweeping zooplankton away from the upwelling, and grazing sardines and anchovies are lacking, then dying phytoplankton will settle on the seabed as they have done off Namibia. As they rot, stripping the bottom water of oxygen and releasing sulphur dioxide and methane, Californians in some coastal communities will be greeted with the stench of bad eggs and rotting fish washed up on their beaches. Through climate change, human actions will have moved the oceans, but not in ways we had planned.

Methane and hydrogen sulphide are both potent greenhouse gases. So, maintaining abundant sardine stocks – to keep phytoplankton in check – could be one approach among many to help counter climate change.[8]

High levels of atmospheric carbon dioxide have another insidious effect – acidification of ocean water. As levels of atmospheric carbon dioxide rise, so more carbon dioxide dissolves in the oceans, creating carbonic acid and making the sea slightly more acidic. Since pre-industrial times, the oceans have absorbed some 30 per cent of the carbon dioxide liberated from human activities. Acidity is measured on the pH scale, with neutrality as pH 7 and acidic being pH values less than 7. The oceans are slightly alkaline (on average, about pH 8.1). Since 1750 the average pH of seawater has dropped by an estimated 0.1 units (from pH 8.2). This sounds marginal, but given that the pH scale is logarithmic (one unit represents a tenfold change) this is a dramatic rise in acidity. For the mid-range of scenarios, seawater acidity is projected to rise

by 38–62 per cent between 2000 and 2100.[9] Small changes in seawater acidity have a significant effect on a very wide range of marine life.

Any organism that builds a shell or outer skeleton out of chalk (calcium carbonate) can be at risk when seawater acidity increases. In places where dissolved carbon dioxide levels are unusually high – for example, where undersea springs contain volcanic gases – the effects on bivalve molluscs such as clams are obvious. They grow paper-thin shells easily crushed between finger and thumb. Numerous other organisms – most notably hard corals that create coral reefs, but also crustaceans, from lobsters to copepods, and some phytoplankton – have outer skeletons containing calcium carbonate. Unless such organisms can adapt rapidly to rising acidity, their exoskeletons will become compromised. The effects would be widespread and difficult to predict. Changes in the success of copepods, for one, would have a profound impact on sardines.

The varying effects of climate change can become compounded. Jellyfish are more resilient than other organisms to low oxygen levels and raised acidity. So, previously successful sardine fisheries could, in worst-case scenarios, be replaced by hordes of jellyfish, as happened off Namibia.[10]

As we have seen, sardine stocks fluctuate in response to natural climatic and other environmental shifts. Add intensive fishing to the equation, plus human-caused climate change, and fluxes in sardine stocks are likely to become even more dramatic and unpredictable.

Can we counter the rise in global atmospheric carbon dioxide levels? Yes, but to do so requires numerous actions at different scales of magnitude – from local to international. This includes continuing research and action to minimize carbon emissions and maximize carbon capture. Maintaining the health of the oceans

plays a role too, with phytoplankton absorbing carbon dioxide in photosynthesis.[11] On a local level, we can vote for politicians who understand the complexity of environmental problems and are willing to act with tenacity and integrity. Whether in the home or workplace, we can take action to lower our energy consumption, reduce wastage and minimize pollution.

There is a precedent for taking action. In 1984 members of the British Antarctic Survey detected an unprecedented thinning of the ozone layer above Antarctica over the previous three years.[12] The ozone layer is protective, absorbing a high proportion of the Sun's ultraviolet radiation before it reaches the Earth. When ozone levels fall – as happens above Antarctica in the spring – more ultraviolet light reaches Earth's surface. This makes skin cancers and eye cataracts more likely for people exposed to it. It also inhibits the growth of plankton in surface waters. At its peak in the southern spring, the ozone hole extends above South Africa and southern Australasia, in places where sardines roam.

The thinning of the ozone layer, dubbed the 'ozone hole', had been rapid. Chlorofluorocarbons (CFCS) – chemicals used as refrigerants, solvents, foam-blowing agents and in a wide variety of aerosols – were identified as the main cause. These and other ozone-depleting substances, when released into the atmosphere, migrate to the stratosphere and in the presence of high levels of ultraviolet radiation liberate forms of chorine and bromine that react aggressively with ozone, so depleting levels in the atmosphere.

In response to this finding, and after a slow start, more than forty countries had signed up to the Montreal Protocol by 1989, aiming to reduce the production of CFCs by half by 1998. When stratospheric ozone thinning was found to be worse than anticipated, signatories to the Protocol agreed to the phasing out of all CFC production by developed countries by 1996.[13] Because of measures taken since, ozone layer depletion appeared to have

stabilized by 2015, although the ozone hole does not look set to be healed until at least 2050, depending on the knock-on effects of other climatic changes. Jon Shanklin, one of the original discoverers of the ozone hole, in 2015 commented, 'Yes, an international treaty was established fairly quickly to deal with the ozone hole, but really the main point about its discovery was that it shows how incredibly rapidly we can produce major changes to our atmosphere and how long it takes for nature to recover from them.'[14]

The ozone hole experience shows that countries can cooperate when the environmental and economic stakes are high. However, the atmospheric greenhouse gas problem is more pervasive and more complex. Nevertheless, in December 2015, 195 countries at the Paris Climate Change Conference (COP21) agreed to a global action plan to turn the tide on greenhouse gas emissions. A long-term goal was to keep the global average temperature to less than 2°C above pre-industrial levels.[15] This seems unlikely and a more realistic scenario given current commitments is that global warming of 2.7 to 3.0°C above pre-industrial levels will happen by 2100.[16] The accuracy and reliability of scientific projections

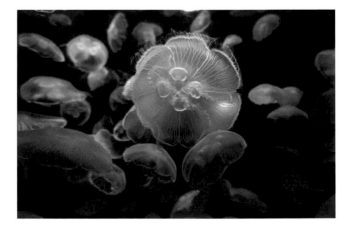

Swarms of jellyfish can be one side effect of depleting numbers of sardines and anchovies in a locality.

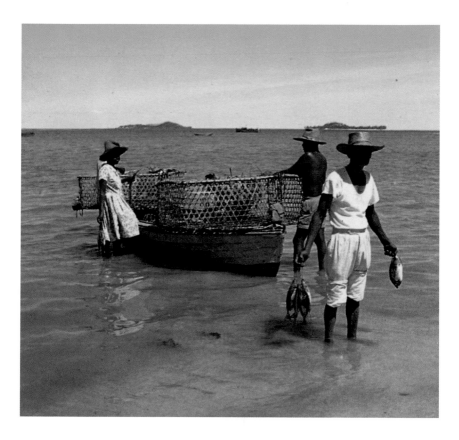

will no doubt improve over the coming decades, and government commitments for action will likely strengthen, but a substantial heating of the Earth will need to be planned for. The multiplicity of its effects – including more intense and prolonged storms, floods, heatwaves and droughts, and rising sea levels and shifting ocean currents – are already being experienced. Unfortunately, many developing countries lie in parts of the world where the impacts of climate change are likely to be greatest, and yet they

Fishermen in low-lying tropical island states, such as here in the Seychelles, are likely to be most severely affected by sea-level rise accompanying global warming.

Ultimately, intergovernmental cooperation is required to safeguard the oceans, as here at the United Nations Climate Change Conference (COP20) in Lima, Peru, in 2014.

are not in a strong position to adapt to or mitigate them. It is here that artisanal fishermen catch sardines for their local communities.

In Europe the effects of climate change on sardines are already being documented. Since the 1990s, as surface waters have warmed, anchovy and sardine populations have moved northwards into the North Sea and Baltic Sea, extending their range from the previous forty years.[17]

As fishers continue to catch sardines, we should value the fish and put them on our menu, rather than allow them to be converted into fishmeal and fish oil. We can become more aware of where the seafood we eat comes from and whether it is caught or cultured using sustainable and environmentally friendly methods. In the UK campaigning chefs Rick Stein and Hugh Fearnley-Whittingstall have raised public awareness on such matters, along with making obscure or unfashionable fish once more in vogue. Fearnley-Whittingstall's campaign to get the European Commission to change its policy on the wasteful dumping of by-catch was highly successful.[18] We can join organizations that are committed to environmental protection and sustainable development.

For every few steps forwards, there are one or two backward moves. On 1 June 2017 President Donald Trump announced that the United States was withdrawing from the 2015 Paris Climate Agreement – the collaborative instrument to curb greenhouse gas emissions.[19] A year earlier, some 52 per cent of those voting in a UK referendum opted to leave the European Union (EU). In Cornwall, England, 56.5 per cent voted to exit. The effects of leaving will be complex. Taking fishing alone, the UK fishing community as a whole might gain but the Cornish sardine industry be worse off. Currently, catching Cornish sardines is profitable and sustainable. But with worsening relations with the EU, managing the fishery (which is connected to fish stocks further south in Atlantic Europe) could become problematic.

The sardine has come to symbolize many aspects of our deep interconnection with nature. On the one hand, sardines playing at the sea surface signify freedom and healthy oceans. On the other, they are a commodity; we alter their populations through fishing, eat them fresh, or package them into tins and grind them up as fish food or fertilizer. We belittle the fish, mocking its size and prevalence.

The sardine is an everyman fish. It is a cheap, cheerful, convenience food for many, and a gourmet's delight for some. To the twentieth-century sardine packers of northwest France and Monterey, processing the fish created workplaces that encouraged sisterly solidarity. To fishing communities, the sardine has fostered fierce allegiances and generated strong cultural traditions that belie its perception as a commonplace fish.

The sardine is humble but resilient. Like the underdog that comes back again and again, as a range of species it will no doubt survive many, many millennia, but in locations and abundances about which we can only speculate. Some of the sardine's most charismatic predators are unlikely to be so lucky. Heightened

consumer awareness and better stewardship of marine fish populations may come too late for some tuna stocks and shark species. They will struggle to survive the twenty-first century.

Sardines will continue to surprise us: whether it is because of what they have come to symbolize in different cultures and ages, a reminder of just how good they taste, or how, despite the best efforts of scientists, their populations behave in unexpected ways. Sardines remind us that the oceans are a vast expanse, and in our understanding, we are still scratching their surface. Sardines also remind us that our actions have consequences. Time and time again, it has been human communities that suffered when the sardine was over-exploited.

On the one hand, attitudes to our relationship with the natural world are becoming more enlightened, but on the other, more people are becoming disconnected from nature. It is not helpful to compartmentalize the fish, to see it as separate from other ocean creatures or as detached from wider environmental concerns. As naturalist John Muir noted way back in 1911, 'When we try to pick out anything by itself, we find it hitched to everything else in the universe.'[20] This applies to the sardine as much as anything else.

Visitors watch a
shoal of sardines
in Monterey
Bay Aquarium's
Open Sea exhibit.
These fish, once
abundant locally,
are currently
scarce.

# Timeline of the Sardine

| *c.* 120 MILLION YEARS AGO | *c.* 18 MILLION YEARS AGO | *c.* 350 BCE | 1ST CENTURY CE |
|---|---|---|---|
| Herring-like fishes have evolved and are abundant in some ancient seas and become preserved as fossils | The ancestors of *Sardina* and *Sardinops* sardines become separated by shifting landmasses | Aristotle in his *History of Animals* refers to fish that are probably European sardines | A Roman cookbook purported to be by Apicius contains a sardine recipe |

| 1851 | 1902–7 | 1910S | 1919 |
|---|---|---|---|
| Wilkie Collins describes the process of catching Cornish pilchards in his travel guide *Rambles Beyond Railways* | In Brittany, France, some 30,000 fishermen and 15,000 women who process the fish lose their jobs when the local sardine fishery collapses  | The traditional Cornish sardine fishery using seine nets has collapsed due to the absence of sardines swimming close to shore | Following the rise of the Californian sardine industry in response to reduced fish supplies from Europe during the First World War, nine sardine canneries have become established in Monterey |

| 1950S | 1968 | 1973 |
|---|---|---|
| In response to plummeting Californian sardine catches, California Cooperative Oceanic Fisheries Investigations (CALCOFI) launch extensive plankton and other sampling surveys off the west coasts of the United States, Canada and Mexico | A record annual catch of sardines for one location – about 1.4 million tonnes – is caught off Namibia | Japanese fishermen protest at Chisso Corporation avoiding compensation for causing mercury pollution. Fishermen dump 5 tonnes of sardines at the gates of Chisso's Minamata factory |

| 1250s | 1558 | 1602 | *c.* 1820 |
|---|---|---|---|
| Salted pilchards are exported from Cornwall, England, to Italy and other Catholic countries in Europe | In his *Historiae animalium*, Conrad Gessner distinguishes European sardines from other fish | Oxford University's library is reopened under the leadership of Thomas Bodley using funds from the Devon pilchard industry | French confectioner Joseph Colin is the first to tin sardines, putting about one hundred sardines in each tin |

| 1924 | 1936–7 | 1945 |
|---|---|---|
| In Douarnenez, Brittany, female sardine packers, *penn sardines*, go on strike over working hours and conditions, and win concessions in a landmark success for French trade unionism | The annual sardine catch off California peaks at its largest ever – 640,000 tonnes | Monterey has become the sardine capital of the world, with over 100 fishing vessels, nineteen canneries and twenty reduction plants |

| 1990s | 2005 | 2015–17 |
|---|---|---|
| Morocco becomes the world's leading sardine catching and canning nation | Startling underwater footage reveals predators attacking sardines at South Africa's Sardine Run in the BBC TV documentary *The Blue Planet* | The biomass of Pacific sardines off North America falls to below 100,000 tonnes and the U.S. commercial sardine fishery is closed for three years in a row |

# References

INTRODUCTION

1  Danny Downing, personal communication, February 2016.
2  Aristotle, *Historia animalium* (*History of Animals*), trans. D'arcy Wentworth Thompson, Book vi, Part 15 (Oxford, 1910).
3  Georges Cuvier and Achille Valenciennes, *Histoire naturelle des poissons* (Paris, 1847), p. 20.
4  W. Van Neer, A. Ervynck and P. Monsieur, 'Fish Bones and Amphorae: Evidence for the Production and Consumption of Salted Fish Products Outside the Mediterranean Region', *Journal of Roman Archaeology*, xxiii/2 (2010), p. 162.
5  Maguelonne Toussaint-Samat, *History of Food*, trans. Anthea Bell (Oxford, 1994), p. 742.
6  Apicius, *Cooking and Dining in Imperial Rome*, ed. and trans. Joseph Dommers Vehling [1936] (New York, 1977), p. 106.
7  Maryanne Kowaleski, 'The Western Fisheries', in *England's Sea Fisheries*, ed. David J. Starkey, Chris Reid and Neil Ashcroft (London, 2000), p. 26.
8  Conrad Gessner, *Historiae animalium liber iv, qui est de piscium et aquatilium animantium natura* (Zurich, 1558).
9  Sophia Hendrikx, 'Identification of Herring Species (*Clupeidae*) in Conrad Gessner's Ichthyological Works: A Case Study on Taxonomy, Nomenclature, and Animal Depiction in the Sixteenth Century', in *Zoology in Early Modern Culture*, ed. Karl A. E. Enenkel and Paul J. Smith (Leiden, 2014), p. 152.
10  Ibid., p. 158.

11 Joseph S. Nelson, *Fishes of the World*, 4th edn (Hoboken, NJ, 2006), pp. 132–4.

12 Ibid.

13 See www.fishbase.org, accessed 22 May 2016.

14 See http://mainesardinemuseum.tripod.com, accessed 2 June 2017.

15 See http://norskhermetikkmuseum.no, accessed 2 June 2017.

16 Henri-Louis Duhamel du Monceau, *Traité général des peches et histoire des poissons*, vol. 1 (Paris, 1769), pp. 106–68.

17 Michael Culley, *The Pilchard: Biology and Exploitation* (Oxford, 1971), pp. 10–11.

18 Demian A. Willette, Kent E. Carpenter and Mudjekeewis D. Santos, 'Evolution of the Freshwater Sardinella, *Sardinella tawilis* (Clupeiformes: Clupeidae), in Taal Lake, Philippines and Identification of Its Marine Sister-species, *Sardinella hualiensis*', *Bulletin of Marine Science*, XC/1 (2014), pp. 1–16.

19 David M. Checkley et al., 'Habitats', in *Climate Change and Small Pelagic Fish*, ed. David M. Checkley et al. (Cambridge, 2009), pp. 12–44.

20 R. H. Parrish, R. Serra and W. S. Grant, 'The Monotypic Sardines, *Sardina* and *Sardinops*: Their Taxonomy, Distribution, Stock Structure and Zoogeography', *Canadian Journal of Fisheries and Aquatic Sciences*, XLI (1989), pp. 414–22.

21 Sébastien Lavoué, Peter Konstantinidis and Wei-Jen Chen, 'Progress in Clupeiform Systematics', in *Biology and Ecology of Sardines and Anchovies*, ed. Konstantinos Ganias (Boca Raton, FL, 2014), pp. 3–42.

22 Jacques Bonnadier, *Le Roman de la sardine* (Avignon, 1994).

23 FAO, *Fishery and Aquaculture Statistics 2014* (Rome, 2016), p. 49.

24 Ibid., p. 12.

1 A HUNTED FISH

1 Karen Bass et al., *Nature's Great Events*, BBC documentary film series (London, 2009).

2   David M. Checkley et al., 'Habitats', in *Climate Change and Small Pelagic Fish*, ed. David M. Checkley et al. (Cambridge, 2009), pp. 12–44.

3   Ibid., pp. 22–6.

4   Andrew Aitken, *Sardine Run: The Greatest Shoal on Earth. A Field Guide to the Sardine Run, Sharks and Other Marine Life on the Eastern Coast of South Africa* (Durban, 2004).

5   Bass, ed., *Nature's Great Events*, pp. 283–95.

6   Callum Roberts, *The Unnatural History of the Sea* (London, 2007).

7   Colin Tudge, *The Variety of Life* (Oxford, 2000), p. 382.

8   Ole Ave Misund and Arvid K. Beltestad, 'Survival of Herring After Simulated Net Bursts and Conventional Storage in Pens', *Fisheries Research*, XXII (1995), pp. 293–7.

9   Quoted in Michael Culley, *The Pilchard: Biology and Exploitation* (Oxford, 1971), p. 151.

10  O. A. Misund et al., 'Schooling Behaviour of Sardine, *Sardinops sagax*, in False Bay, South Africa', *African Journal of Marine Science*, XXV (2003), pp. 185–93.

11  Hannah Waters, 'Now in 3-D: The Shape of Krill and Fish Schools', http://blogs.scientificamerican.com, 10 November 2010.

12  Steven Vogel, *Cats' Paws and Catapults* (London, 1998), p. 257.

13  Andrew Backun, 'The Oxygen Constraint', in *Ecosystem Approaches to Fisheries: A Global Perspective*, ed. V. Christensen and J. Maclean (Cambridge, 2011), pp. 11–23.

14  Mark W. Denny, *Air and Water: The Biology and Physics of Life's Media* (Princeton, NJ, 1993), p. 73.

15  Backun, 'The Oxygen Constraint', pp. 13–22.

16  Mostafa Ali Salem, 'Structure and Function of the Retinal Pigment Epithelium, Photoreceptors and Cornea in the Eye of *Sardinella aurita* (Clupeidae, Teleostei)', *Journal of Basic and Applied Zoology*, LXXV (2016), pp. 1–12.

17  Trevor Day, *Oceans*, 2nd edn (New York, 2008), pp. 67–9.

18  Quentin Bone and Richard H. Moore, *Biology of Fishes*, 3rd edn (Abingdon, 2008), pp. 296–301.

19  Ibid., pp. 299–301.

20  B. Wilson et al., 'Pacific and Atlantic Herring Produce Burst Pulse
    Sounds', *Proceedings of the Royal Society of London B (Supplement)*,
    CCLXXI (2003), pp. 95–7.
21  Bone and Moore, *Biology of Fishes*, pp. 77–81.
22  Joseph S. Nelson, *Fishes of the World*, 4th edn (Hoboken, NJ, 2006),
    pp. 100–101.
23  G. J. Vermeij, *Evolution and Escalation: An Ecological History of Life*
    (Princeton, NJ, 1987).
24  Panagiotis Kasapidis, 'Phylogeography and Population Genetics',
    in *Biology and Ecology of Sardines and Anchovies*, ed. Konstantinos
    Ganias (Boca Raton, FL, 2014), pp. 61–7.

2  A QUICKSILVER FISH IN A STRANGE WORLD

1   C. F. Hickling, 'The Seasonal Cycle in the Cornish Pilchard', *Journal
    of the Marine Biological Association*, XXVI/2 (1945), pp. 115–38.
2   Trevor Day, *Oceans*, 2nd edn (New York, 2008).
3   Willie Wilson, pers. comm., February 2016.
4   I. S. Robinson and T. Guymer, 'Observing Oceans from Space', in
    *Oceanography: An Illustrated Guide*, ed. C. P. Summerhayes and S.
    A. Thorpe (London, 1996), pp. 69–88.
5   Hickling, 'The Seasonal Cycle in the Cornish Pilchard', pp. 115–38.
6   D. C. Boyer and I. Hampton, 'An Overview of the Living Marine
    Resources of Namibia', *South African Journal of Marine Science*,
    XXIII/1 (2001), p. 16.
7   Lisa-ann Gershwin, *Stung! On Jellyfish Blooms and the Future of the
    Ocean* (Chicago, IL, 2013), pp. 37–40.
8   Ibid., pp. 43–57.
9   Ibid.
10  Manuel Barange et al., 'Current Trends in the Assessment
    and Management of Stocks', in *Climate Change and Small
    Pelagic Fish*, ed. David M. Checkley et al. (Cambridge, 2009),
    pp. 213–15.
11  Michael Culley, *The Pilchard: Biology and Exploitation* (Oxford,
    1971), pp. 35–6.

12 Quentin Bone and Richard H. Moore, *Biology of Fishes*, 3rd edn (Abingdon, 2008), p. 247.

13 Reuben Lasker, 'The Role of a Stable Ocean in Larval Fish Survival and Subsequent Recruitment', in *Marine Fish Larvae: Morphology, Ecology and Relation to Fisheries*, ed. Reuben Lasker (Seattle, WA, 1981), pp. 80–87.

14 Susana Garrido and Carl David van der Lingen, 'Feeding Biology and Ecology', in *Biology and Ecology of Sardines and Anchovies*, ed. Konstantinos Ganias (Boca Raton, FL, 2014), pp. 123–5.

15 Alister C. Hardy, *The Open Sea – Its Natural History: The World of Plankton* (London, 1956).

16 'The Continuous Plankton Recorder', www.sahfos.ac.uk, accessed 29 May 2017.

17 Jennifer Skinner, pers. comm., February 2016.

18 M. Edwards et al., *Fish Larvae Atlas of the NE Atlantic: Results from the Continuous Plankton Recorder Survey, 1948–2005* (Plymouth, 2011), pp. 4–5.

19 Martin Edwards et al., 'Marine Ecosystem Response to the Atlantic Multidecadal Oscillation', *PLOS ONE*, VIII/2 (2013), e57212.

20 Priscilla Licandro, pers. comm., February 2016.

21 Mark D. Ohman and Elizabeth L. Venrick, 'CalCOFI in a Changing Ocean', *Oceanography*, XVI/3 (2003), pp. 76–85.

22 See http://calcofi.org, accessed 29 May 2017.

23 Ohman and Venrick, 'CalCOFI', pp. 76–85.

24 C. H. Hsieh et al., 'Fishing Elevates Variability in the Abundance of Exploited Species', *Nature*, CDXLIII (2006), pp. 859–62.

3 FORTUNES WON

1 Augustine Birrell, *The Collected Essays and Addresses of the Rt. Hon. Augustine Birrell, 1880–1920*, vol. III (London, 1922), p. 188.

2 'The Bodleian Library, Oxford', illustrated brochure, www.bodleian.ox.ac.uk, accessed 23 May 2016.

3 Ibid.

4  Thomas Bodley, *The Life of Sir Thomas Bodley* (Oxford, 1647).

5  Cyril Noall, *Cornish Seines and Seiners* (Truro, 1972), p. 12.

6  Richard Carew, *The Survey of Cornwall* (London, 1602), p. 32.

7  Daniel Defoe, *Tour Through the Whole Island of Great Britain*, vol. I [1724] (London, 1962), pp. 225–6.

8  W. Wilkie Collins, *Rambles Beyond Railways; or, Notes in Cornwall Taken A-foot* [1851] (London, 1861), pp. 120–39; Michael Culley, *The Pilchard: Biology and Exploitation* (Oxford, 1971), pp. 51–6; Keith Harris, *Hevva! Cornish Fishing in the Days of Sail* [1983] (Truro, 2010), pp. 44–7; Noall, *Cornish Seines and Seiners*, pp. 26–59.

9  Collins, *Rambles Beyond Railways*, p. 127.

10  Ibid., pp. 130–31.

11  Thomas Moule, *The Heraldry of Fish* (London, 1842), p. 160.

12  Ibid., p. 161.

13  Culley, *The Pilchard*, pp. 53–4.

14  Ibid., p. 54.

15  Noall, *Cornish Seines and Seiners*, p. 25.

16  Ibid., pp. 60–106.

17  Ibid., pp. 73–4.

18  Brian Stevens, pers. comm., May 2016.

19  Ibid.

20  Tim Thomas, 'Monterey Bay's Fishing History', www.youtube.com, 26 August 2011.

21  Michael Kenneth Hemp, *Cannery Row: The History of John Steinbeck's Old Ocean View Avenue* (Carmel, CA, 2009), p. 42.

22  Culley, *The Pilchard*, p. 144.

23  Thomas, 'Monterey Bay's Fishing History'.

24  Will F. Thompson, 'The California Sardine and the Study of the Available Supply', *Fish Bulletin, Calif.*, XI (1926), pp. 7–66, p. 7.

25  Culley, *The Pilchard*, pp. 165–8.

26  Hemp, *Cannery Row*, pp. 56–61.

27  Tim Thomas, pers. comm., June 2016.

28  Hemp, *Cannery Row*, p. 67.

29 E. H. Ahlstrom and J. Radovich, 'Management of the Pacific Sardine', in *A Century of Fisheries in North America*, ed. N. G. Benson (Washington, DC, 1970), pp. 183–93.

30 Cited in Culley, *The Pilchard*, p. 170.

31 Ibid., pp. 166–72.

32 Ibid., p. 171.

33 Ibid.

34 Randall A. Reinstedt, *Where Have All the Sardines Gone?* (Carmel, CA, 1978), p. 16.

35 Kevin T. Hill, Paul R. Crone and Juan P. Zwolinski, *Assessment of the Pacific Sardine Resource in 2017 for USA Management in 2017–18* (Portland, OR, 2017), pp. 8–16.

36 John Steinbeck, *Cannery Row* [1945] (London, 2000).

37 Ibid., pp. 5–6.

38 Ibid., p. 4.

39 John Steinbeck, 'From *About Ed Ricketts*', in *Of Men and Their Making: The Selected Nonfiction of John Steinbeck*, ed. Susan Shillinglaw and Jackson J. Benson (London, 2002), pp. 179–212.

40 Steinbeck, *Cannery Row*, p. 95.

41 Ibid., p. 117.

42 Edward F. Ricketts and John Calvin, *Between Pacific Tides* (Stanford, CA, 1939).

43 Katharine A. Rodger, *Breaking Through: Essays, Journals, and Travelogues of Edward F. Ricketts* (Berkeley, CA, 2006), p. 72.

44 Steinbeck, *Cannery Row*, p. xi.

45 Ibid.

46 C. P. Snow, *The Two Cultures and the Scientific Revolution* (Cambridge, 1959).

47 John Steinbeck and Edward F. Ricketts, *Sea of Cortez: A Leisurely Journal of Travel and Research* (New York, 1941), p. 1.

48 Ibid., p. 7.

49 Hemp, *Cannery Row*, p. 107.

50 Cristina Pita et al., 'Socioeconomics and Management', in *Biology and Ecology of Sardines and Anchovies*, ed. Konstantinos Ganias (Boca Raton, FL, 2014), pp. 335–66.

51 R. J. Whittington et al., 'Herpesvirus that Caused Epizootic Mortality in 1995 and 1998 in Pilchard, *Sardinops sagax neopilchardus* (Steindachner), in Australia is now Endemic', *Journal of Fish Diseases*, 31 (2008), pp. 97–105.

52 Manuel Barange et al., 'Current Trends in the Assessment and Management of Stocks', in *Climate Change and Small Pelagic Fish*, ed. David M. Checkley et al. (Cambridge, 2009), pp. 206–7.

53 Rodger, *Breaking Through*, pp. 324–30.

### 4 TO EAT A SARDINE

1 Max Adams, pers. comm., June 2016.

2 Charles L. Cutting, *Fish Saving: A History of Fish Processing from Ancient to Modern Times* (London, 1955), pp. 79–82.

3 Ibid., pp. 79–81.

4 Maguelonne Toussaint-Samat, *History of Food*, trans. Anthea Bell (Oxford, 1994), p. 322.

5 Susan Featherstone, *Volume III: Processing Procedures for Canned Food Products*, 14th edn (Cambridge, 2016), pp. 53–4.

6 Cutting, *Fish Saving*, pp. 187–8.

7 Sue Shepherd, *Pickled, Potted and Canned: How the Art and Science of Food Preserving Changed the World* (New York, 2006), p. 241.

8 Alain Drouard, 'The History of the Sardine-canning Industry in France in the Nineteenth and Twentieth Centuries', in *Food Production and Food Processing in Western Europe, 1850–1990*, ed. Y. Segers, J. Bieleman and E. Buyst (Turnhout, 2009), pp. 186–7.

9 Ibid., pp. 185–6.

10 Marine Stewardship Council, 'Portuguese Sardine Fishery Update: Suspension of MSC Certification', www.msc.org, 22 September 2014.

11 Marvine Howe, 'Fare of the Country; In Portugal, Fresh Sardines', *New York Times*, 24 June 1990.

12 Jo Gascoigne, *Moroccan Sardine Fishery: Assessment in Relation to the MSC Standard* (Honolulu, HI, 2016).

13 Alexandra Silva et al., *European Parliament Research Report: Sardine Fisheries: Resource Assessment and Social and Economic Situation* (Brussels, 2015).

14 Featherstone, *Processing Procedures*, pp. 73–4.

15 Ibid., p. 661.

16 Ibid., pp. 674–84.

17 Palaniappan Saravanan et al., 'Cardiovascular Effects of Marine Omega-3 Fatty Acids', *Lancet* (16 July 2010), pp. 1–11.

18 See www.cochrane.org, accessed 28 June 2016.

19 Danielle Swanson, Robert Block and Shaker A. Mousa, 'Omega-3 Fatty Acids EPA and DHA: Health Benefits throughout Life', *Advances in Nutrition*, III/1 (2012), pp. 1–7.

20 'What Shape Are Tuna Stocks In?', http://worldoceanreview.com, accessed 20 June 2016.

21 'Japan Bluefin Tuna Fetches Record $1.7m', www.bbc.co.uk, 5 January 2013.

22 International Scientific Committee for Tuna and Tuna-like species in the North Pacific Ocean, 'Stock Status and Conservation Advice', http://isc.fra.go.jp, accessed 20 June 2016.

23 FAO, *The State of World Fisheries and Aquaculture, 2016* (Rome, 2016), p. 39.

24 Tom Levitt, 'Is It OK to Eat Farmed Salmon Now?', www.theguardian.com, 29 September 2015.

25 Steven Morris, 'Salted Pilchard Tradition Dies as Last Cornish Factory Shuts', www.theguardian.com, 30 July 2005.

26 Hugh Fearnley-Whittingstall and Nick Fisher, *The River Cottage Fish Book*, revd edn (London, 2010), pp. 148–9.

27 Jacques Bonnadier, *Le Roman de la sardine* (Avignon, 1994), pp. 105–55.

28 Ibid., p. 14.

29 'Specialities at Tokyo Restaurant are Endless Variety of Sardines', *Milwaukee Journal*, 25 July 1956, p. 1.

30 Jay Friedman, 'Snapshots from Japan: Sardine Lunch at *Nakajima* in Tokyo', www.seriouseats.com, 5 August 2013.

31 FAO, *The State of World Fisheries and Aquaculture, 2016*, p. 3.

32 FAO, *The State of World Fisheries and Aquaculture, 2014* (Rome, 2014), p. 7.

33 Cutting, *Fish Saving*, p. 326.

5 FORTUNES LOST

1 Thomas Huxley, 'Inaugural Address to the Fisheries Exhibition, London, 1883', http://alepho.clarku.edu/huxley/sm5/fish.html, accessed 25 June 2016.

2 'Monterey Bay Fisheries Trust: Preserving Local Catch for Local Fishermen', https://futureoftheocean.wordpress.com, accessed 25 June 2016.

3 Kevin T. Hill, Paul R. Crone and Juan P. Zwolinski, *Assessment of the Pacific Sardine Resource in 2017 for USA Management in 2017–18* (Portland, OR, 2017), pp. 8–16.

4 Callum Roberts, *The Unnatural History of the Sea* (London, 2007).

5 Quoted in Jean-Christophe Fichou, 'La crise sardinière de 1902–1913 au Coeur des affrontements religieux en Bretagne', *Annales de Bretagne et Des Pays de l'Ouest*, CXVI/4 (2009), p. 156.

6 Ibid., p. 151.

7 Ibid., p. 150.

8 Ibid., pp. 149–70.

9 Solange Hando, *Paris: Memories of Times Past* (San Diego, CA, 2008), p. 112.

10 Fichou, 'La crise sardinière de 1902–1913', p. 161.

11 R. Ian Perry et al., 'Marine Social–Ecological Responses to Environmental Change and the Impacts of Globalization', *Fish and Fisheries*, XII/4 (2011), pp. 434–6.

12 Garrett Hardin, 'The Tragedy of the Commons', *Science*, CLXII (1968), pp. 1243–8.

13 Roberts, *Unnatural History of the Sea*.

14 Simon Jennings, Michael J. Kaiser and John D. Reynolds, *Marine Fisheries Ecology* (Oxford, 2001), pp. 127–58.

15 Ibid., p. 127.

16 Pierre Fréon et al., 'Sustainable Exploitation of Small Pelagic Fish

Stocks Challenged by Environmental and Ecosystem Changes: A Review', *Bulletin of Marine Science*, LXXVI/2 (2005), pp. 385–462.

17  Alec D. MacCall, 'A Short Scientific History of the Fisheries', in *Climate Change and Small Pelagic Fish*, ed. David M. Checkley et al. (Cambridge, 2009), pp. 6–11.

18  Charles J. Krebs, *The Ecological World View* (Oakland, CA, 2008), p. 427.

19  Tim R. Baumgartner et al., 'Reconstruction of the History of the Pacific Sardine and Northern Anchovy Populations over the Last Two Millennia from Sediments of the Santa Bay Basin, California', *CalCOFI Reports*, XXXIII (1992), pp. 24–40.

20  Jürgen Alheit, Claude Roy and Souad Kifani, 'Decadal-scale Variability in Populations', in *Climate Change and Small Pelagic Fish*, ed. David M. Checkley et al. (Cambridge, 2009), pp. 64–87.

21  Peter Fimrite, 'Sardine Population Collapses, Prompting Ban on Commercial Fishing', www.sfgate.com, accessed 25 June 2016.

22  Fréon et al., 'Sustainable Exploitation of Small Pelagic Fish Stocks Challenged', p. 399.

23  Ibid., pp. 385–462.

24  MacCall, 'A Short Scientific History of the Fisheries', p. 10.

25  Cristina Pita et al., 'Socioeconomics and Management', in *Biology and Ecology of Sardines and Anchovies*, ed. Konstantinos Ganias (Boca Raton, FL, 2014), pp. 335–66.

26  World Commission on the Ethics of Scientific Knowledge and Technology (COMEST) and UNESCO, *The Precautionary Principle* (Paris, 2005), pp. 9–12.

27  Fréon et al., 'Sustainable Exploitation of Small Pelagic Fish Stocks Challenged', pp. 434–44.

28  Kevin T. Hill, Paul R. Crone and Juan P. Zwolinski, *Assessment of the Pacific Sardine Resource in 2017 for USA Management in 2017–18* (Portland, OR, 2017), pp. 9–10.

29  Ibid., p. 12.

30  Pacific Fishery Management Council, 'Council Votes to Close Pacific Sardine Fishery for Third Year in a Row', www.pcouncil.org, 11 April 2017.

## 6 CULTURAL SARDINES

1 W. Heywood, *The Little Flowers of St Francis* (London, 1906), pp. 101–2.
2 Fred Licht, *Goya: The Origins of the Modern Temper in Art* (London, 1980), p. 202.
3 James Hall, *Dictionary of Subjects and Symbols in Art*, revd edn (London, 1979), p. 122.
4 Hope B. Werness, *The Continuum Encyclopedia of Animal Symbolism in Art* (New York, 2003), p. 175.
5 Ibid., p. 202.
6 James Hall, *Illustrated Dictionary of Symbols in Eastern and Western Art* (New York, 1994), p. 24.
7 Werness, *Animal Symbolism*, pp. 178–9.
8 Hou-mei Sung, *Decoded Messages: The Symbolic Language of Chinese Animal Painting* (New Haven, CT, 2009), pp. 207–44.
9 L. C. Reis and J. R. Hibbeln, 'Cultural Symbolism of Fish and the Psychotropic Properties of Omega-3 Fatty Acids', *Prostaglandins, Leukotrienes and Essential Fatty Acids*, LXXV (2006), pp. 227–36.
10 Ibid., pp. 229–35.
11 See www.cochrane.org, accessed 28 June 2016.
12 Werness, *Animal Symbolism*, p. 180.
13 Dirk Bax, *Hieronymus Bosch: His Picture-writing Deciphered*, trans. M. A. Bax-Botha (Rotterdam, 1979), pp. 42–4.
14 Wilhelm Fraenger, *Hieronymus Bosch*, trans. Helen Sebba (London, 1989), p. 133.
15 Alain Drouard, 'The History of the Sardine-canning Industry in France in the Nineteenth and Twentieth Centuries', in *Food Production and Food Processing in Western Europe, 1850–1990*, ed. Y. Segers, J. Bieleman and E. Buyst (Turnhout, 2009), pp. 187–8.
16 Ibid., p. 182.
17 Ibid., pp. 186–7.
18 Ibid., p. 187.
19 Nathalie Alony, 'Home Sweet Home', http://natalica.com, accessed 5 June 2016.

20 Rachel Roberts et al., 'Fiona Hall', www.australia.gov.au, accessed 3 February 2016.

21 Sid Chaplin, *The Day of the Sardine* [1961], new edn (London, 1989).

22 Dinah Birch and Margaret Drabble, eds, *The Oxford Companion to English Literature*, 7th edn (Oxford, 2009), pp. 832–3.

23 Chaplin, *Day of the Sardine*, p. 24.

24 Juan José Arévalo, *The Shark and the Sardines* (New York, 1961).

25 Paul J. Dosal, *Doing Business with the Dictators: A Political History of United Fruit in Guatemala, 1899–1944* (Wilmington, DE, 1993).

26 Stephen Schlesinger and Stephen Kinzer, *Bitter Fruit: The Story of the American Coup in Guatemala*, expanded edn (Cambridge, MA, 1999); Edward R. Kantowicz, *Coming Apart, Coming Together* (Grand Rapids, MI, 2000), pp. 322–41.

27 Andrew Ezergailis, *The Holocaust in Latvia, 1941–1944* (Washington, DC, 1996), pp. 240–42.

28 Richard L. Rubenstein and John K. Roth, *Approaches to Auschwitz: The Holocaust and its Legacy* (Atlanta, GA, 1987), pp. 129–30.

29 Emmanuel Guibert and Joann Sfar, *Sardine in Outer Space* (New York, 2006).

30 Stephen Knight, *Sardines and Other Poems* (London, 2005), pp. 1–3.

31 J. McCurry, 'Japan Remembers Minamata', *Lancet*, CCCLXVII/9505 (2006), pp. 99–100.

32 Andrew L. Jenks, *Perils of Progress: Environmental Disasters in the Twentieth Century* (Boston, MA, 2011), pp. 13–42.

33 Robinson Jeffers, *The Selected Poetry of Robinson Jeffers* (New York, 1938), pp. 588–9.

34 Spike Milligan, *A Children's Treasury of Milligan* (London, 1999), p. 69.

35 Alan Travis, 'The Night Yogi and Boo-Boo Helped Semolina Pilchard Snare a Beatle', www.theguardian.com, 1 August 2005.

7 PROSPECT

1 P. Kasapidis, 'Phylogeography and Population Genetics', in *Biology and Ecology of Sardines and Anchovies*, ed. Konstantinos Ganias (Boca Raton, FL, 2014), pp. 61–70.

2 David B. Field, et al., 'Variability from Scales in Marine Sediments and Other Historical Records', in *Climate Change and Small Pelagic Fish*, ed. David M. Checkley et al. (Cambridge, 2009), pp. 45–63.

3 IPCC, *Climate Change 2014, Synthesis Report, Summary for Policymakers* (Cambridge, 2014), pp. 10–11.

4 T. J. Blasing, 'Recent Greenhouse Gas Concentrations', http://cdiac.ornl.gov, 13 April 2016.

5 IPCC, *Climate Change 2014*, pp. 10–13.

6 Callum Roberts, *Ocean of Life* (London, 2012), pp. 65–8.

7 Andrew Bakun, 'Global Climate Change and Intensification of Coastal Ocean Upwelling', *Science*, CCXLVII (1990), pp. 198–201.

8 A. Andrew Bakun and Scarla J. Weeks, 'Greenhouse Gas Buildup, Sardines, Submarine Eruptions and the Possibility of Abrupt Degradation of Intense Marine Upwelling Ecosystems', *Ecology Letters*, VII (2005), pp. 1015–23.

9 IPCC, *Climate Change 2014*, p. 12.

10 Lisa-ann Gershwin, *Stung! On Jellyfish Blooms and the Future of the Ocean* (Chicago, IL, 2013), pp. 37–9.

11 IPCC, *Climate Change 2014*, pp. 17–31.

12 Karin L. Gleason, 'Science: The Antarctic Ozone Hole', www.ozonelayer.noaa.gov, 20 March 2008.

13 U.S. Environmental Protection Agency, 'Ozone Depletion: The Facts Behind the Phaseout', http://ateam.lbl.gov, accessed 24 June 2016.

14 Robin McKie, 'Thirty Years On, Scientist Who Discovered Ozone Layer Hole Warns: "It Will Still Take Years to Heal"', www.theguardian.com, 18 April 2015.

15 European Commission, 'Paris Agreement', http://ec.europa.eu, accessed 24 June 2016.

16 Fiona Harvey, 'Paris Climate Change Agreement: The World's Greatest Diplomatic Success', www.theguardian.com, 14 December 2015.

17 Jürgen Alheit et al., 'Climate Variability Drives Anchovies and Sardines into the North and Baltic Seas', *Progress in Oceanography*, XCVI (2012), pp. 128–39.

18  See www.fishfight.net, accessed 28 June 2016.

19  'Paris Climate Deal: Dismay as Trump Signals Exit from Accord', www.bbc.co.uk/news, accessed 2 June 2017.

20  John Muir, *My First Summer in the Sierra* [1911] (San Francisco, CA, 1988), p. 110.

# Select Bibliography

Ahlstrom, E. H., and J. Radovich, 'Management of the Pacific Sardine',
in *A Century of Fisheries in North America*, ed. N. G. Benson
(Washington, DC, 1970), pp. 183–93

Aitken, Andrew, *Sardine Run: The Greatest Shoal on Earth*
(Durban, 2004)

Bass, Karen, ed., *Nature's Great Events* (London, 2009).

Baumgartner, Tim R., et al., 'Reconstruction of the History of the
Pacific Sardine and Northern Anchovy Populations over the Last
Two Millennia from Sediments of the Santa Bay Basin, California',
*calcofi Reports*, 33 (1992), pp. 24–40

Beegel, Susan F., Susan Shillinglaw and Wesley N. Tiffney Jr,
*Steinbeck and the Environment: Interdisciplinary Approaches*
(Tuscaloosa, AL, 1997)

Bonnadier, Jacques, *Le Roman de la sardine* (Avignon, 1994)

Checkley, David M. Jr, Jürgen Alheit, Yoshioki Oozeki and Claude Roy,
eds, *Climate Change and Small Pelagic Fish* (Cambridge, 2009)

—, Rebecca G. Asch and Ryan R. Rykaczewski, 'Climate, Anchovy, and
Sardine', *Annual Review of Marine Science*, IX (2017), pp. 469–93

Christensen, Villy, and Jay Maclean, eds, *Ecosystem Approaches to
Fisheries: A Global Perspective* (Cambridge, 2011)

Collins, W. Wilkie, *Rambles Beyond Railways; or, Notes in Cornwall
Taken A-foot* (London, 1851)

Culley, Michael, *The Pilchard: Biology and Exploitation* (Oxford, 1971)

Cutting, Charles L., *Fish Saving: A History of Fish Processing from
Ancient to Modern Times* (London, 1955)

Day, Trevor, *Oceans*, revd edn (New York, 2008)

Denny, Mark W., *Air and Water: The Biology and Physics of Life's Media* (Princeton, NJ, 1993)

Drouard, Alain, 'The History of the Sardine-canning Industry in France in the Nineteenth and Twentieth Centuries', in *Food Production and Food Processing in Western Europe, 1850–1990*, ed. Y. Segers, J. Bieleman and E. Buyst (Turnhout, 2009), pp. 177–90

Edwards, M., et al., *Fish Larvae Atlas of the NE Atlantic: Results from the Continuous Plankton Recorder Survey, 1948–2005* (Plymouth, 2011)

Edwards, Martin, et al., 'Marine Ecosystem Response to the Atlantic Multidecadal Oscillation', *PLOS ONE*, VIII/2 (2013), e57212

FAO, *Fishery and Aquaculture Statistics, 2015* (Rome, 2017)

—, *The State of World Fisheries and Aquaculture, 2016* (Rome, 2016)

Fearnley-Whittingstall, Hugh, and Nick Fisher, *The River Cottage Fish Book*, revd edn (London, 2010)

Ferguson, John, *Remains of the Pilchard Fishery of St Ives and West Cornwall* (St Ives, 2014)

Fichou, Jean-Christophe, 'La Crise sardinière de 1902–1913 au Coeur des affrontements religieux en Bretagne', *Annales de Bretagne et des pays de l'ouest*, CXVI/4 (2009), pp. 149–70

Fréon, Pierre, Philippe Cury, Lynne Shannon and Claude Roy, 'Sustainable Exploitation of Small Pelagic Fish Stocks Challenged by Environmental and Ecosystem Changes: A Review', *Bulletin of Marine Science*, LXXVI/2 (2005), pp. 385–462

Ganias, Konstantinos, ed., *Biology and Ecology of Sardines and Anchovies* (Boca Raton, FL, 2014)

Gershwin, Lisa-ann, *Stung! On Jellyfish Blooms and the Future of the Ocean* (Chicago, IL, 2013)

Hardy, Alister C., *The Open Sea – Its Natural History: The World of Plankton* (London, 1956)

Harris, Keith, *Hevva! Cornish Fishing in the Days of Sail*, 2nd edn (Truro, 2010)

Hemp, Michael K., *Cannery Row: The History of John Steinbeck's Old Ocean View Avenue* (Carmel, CA, 2009)

Hendrikx, Sophia, 'Identification of Herring Species (*Clupeidae*) in Conrad Gessner's Ichthyological Works: A Case Study on Taxonomy, Nomenclature, and Animal Depiction in the Sixteenth Century', in *Zoology in Early Modern Culture*, ed. Karl A. E. Enenkel and Paul J. Smith (Leiden, 2014), pp. 149–71

Hickling, C. F., 'The Seasonal Cycle in the Cornish Pilchard', *Journal of the Marine Biological Association UK*, XXVI/2 (1945), pp. 115–38

Hsieh, C. H., et al., 'Fishing Elevates Variability in the Abundance of Exploited Species', *Nature*, CDXLIII (2006), pp. 859–62

IPCC, *Climate Change 2014, Synthesis Report, Summary for Policymakers* (Cambridge, 2014)

Jennings, Simon, Michael J. Kaiser and John D. Reynolds, *Marine Fisheries Ecology* (Oxford, 2001)

Moule, Thomas, *The Heraldry of Fish* (London, 1842)

Nelson, Joseph S., *Fishes of the World*, 4th edn (Hoboken, NJ, 2006)

Noall, Cyril, *Cornish Seines and Seiners* (Truro, 1972)

Nybakken, James W., and Mark D. Bertness, *Marine Biology: An Ecological Approach*, 6th edn (San Francisco, CA, 2004)

Ohman, Mark D., and Elizabeth L. Venrick, 'CalCOFI in a Changing Ocean', *Oceanography*, XVI/3 (2003), pp. 76–85

Parrish, R. H., R. Serra and W. S. Grant, 'The Monotypic Sardines, *Sardina* and *Sardinops*: Their Taxonomy, Distribution, Stock Structure and Zoogeography', *Canadian Journal of Fisheries and Aquatic Sciences*, XLVI (1989), pp. 2019–26

Pauly, Daniel, 'Anecdotes and the Shifting Baseline Syndrome of Fisheries', *Trends in Ecology and Evolution*, X/10 (1995), p. 430

Peschak, Thomas, and Claudio Rojas, *Currents of Contrast: Life in South Africa's Two Oceans* (Cape Town, 2006)

Ricketts, Edward F., *Breaking Through: Essays, Journals, and Travelogues of Edward F. Ricketts*, ed. Katharine A. Rodger (Los Angeles, CA, 2016)

—, and John Calvin, *Between Pacific Tides* (Stanford, CA, 1939)

Roberts, Callum, *The Unnatural History of the Sea* (London, 2007)

—, *Ocean of Life* (London, 2012)

Stein, Rick, *Fish and Shellfish*, revd edn (London, 2014)

Steinbeck, John, *Cannery Row* (New York, 1945; London, 2000)
—, and Edward F. Ricketts, *Sea of Cortez: A Leisurely Journal of Travel and Research* (New York, NY, 1941)
Tudge, Colin, *The Variety of Life* (Oxford, 2000)
Ueber, E., and A. MacCall, 'The Rise and Fall of the Californian Sardine Empire', in *Climate Variability, Climate Change and Fisheries*, ed. M. H. Glantz (Cambridge, 1992), pp. 31–48
Vogel, Steven, *Life in Moving Fluids*, 2nd edn (Princeton, NJ, 1994)
Webster, D. G., *Beyond the Tragedy in Global Fisheries* (Cambridge, MA, 2015)

# Associations and Websites

AQUACULTURE STEWARDSHIP COUNCIL
www.asc-aqua.org

CALCOFI (CALIFORNIA COOPERATIVE OCEANIC FISHERIES
INVESTIGATIONS)
http://calcofi.org

CALIFORNIA ACADEMY OF SCIENCES CATALOGUE OF FISHES
http://researcharchive.calacademy.org/research/ichthyology/
catalog/fishcatmain.asp

CANNERY ROW FOUNDATION
www.canneryrow.org

CANNERY ROW, MONTEREY, CALIFORNIA (OFFICIAL SITE)
www.canneryrow.com

FAO FISHERIES AND AQUACULTURE DEPARTMENT
www.fao.org/fishery/en

FISHBASE
www.fishbase.org

FISHWATCH: U.S. SEAFOOD FACTS
www.fishwatch.gov/eating-seafood/health

MARINE CONSERVATION SOCIETY'S GOOD FISH GUIDE
www.goodfishguide.org

MARINE STEWARDSHIP COUNCIL
www.msc.org

PACIFIC FISHERY MANAGEMENT COUNCIL
www.pcouncil.org

SARDINE KING, VINTAGE CALIFORNIA SARDINE CAN LABELS
www.sardineking.com

SEA AROUND US – FISHERIES, ECOSYSTEMS AND BIODIVERSITY
www.seaaroundus.org

SIR ALISTER HARDY FOUNDATION FOR OCEAN SCIENCE (SAHFOS)
www.sahfos.ac.uk

WORLD OCEAN REVIEW
http://worldoceanreview.com

THE ZWAZULU-NATAL SHARKS BOARD SARDINE RUN WEBPAGES
www.shark.co.za/Pages/Sardinerun

# Acknowledgements

The Roger Deakin Trust, which is administered by the Society of Authors, UK, funded my research field trip to California, United States, and Baja California, Mexico, which informed the writing of this book. Without the support of Steve Cook and David Swinburne, my managers at the Royal Literary Fund, I would not have been able to fund and arrange the field research in Portugal, South Africa and in the UK. To both the Society of Authors and the Royal Literary Fund, my great thanks.

Interviews with many people informed the content of this book and some helped organize encounters with living sardines, their predators and fishermen, which helped bring the sardine story to life. Some also kindly read extracts from the book in progress, to check their veracity. I, of course, take responsibility for the results of such interactions that appear in this book.

I would particularly like to thank the following, for their help at different legs of the physical and literary journey. In Baja California, Mexico: Octavio Aburto-Oropeza, Lorena Carrizosa and Unai Maikaida. In Umkomass and Port St Johns, South Africa: Leon Joubert, Ferdi Oosthuizen, Claudia Pellarini-Joubert, Dietmar Posch and Rafaella Schlegel. In Peniche, Portugal: João Correia. In Monterey and San Diego, California, and New York: Scott Cassell, Dennis Copeland, Brad Erisman, William Gilly, Phil Hastings, Maryanne Kowaleski, Mark Ohman, Richard Parrish and Tim Thomas. In the UK: Max Adams, Mark Cocker, Mary Deane, Danny Downing, Juli Féjer, Stefan Glinski, Katie Grant, Nick Halliday, Paul Kingsnorth, Priscilla Licandro, Jennifer Skinner, Matt Slater, Brian Stevens, Katherine Stansfield, Jeremy Wade, Andrew Wheeler and

Willie Wilson. Plus appreciation to staff at the following libraries: Bodleian Library, Oxford; British Library, London; London Library; National Oceanographic Library, Southampton; Scripps Institution of Oceanography Library, California.

Special thanks to those at Reaktion Books – series editor Jonathan Burt, picture handler Harry Gilonis, text editor Amy Salter and proof-reader Emma Wiggin – who between them brought their expertise to bear in shaping the final book.

Finally, heartfelt thanks to my wife, Christina, who as ever is prepared to protect my time and space to write, and is even happy to read what I create.

# Photo Acknowledgements

The authors and publishers wish to express their thanks to the following sources of illustrative material and/or permission to reproduce it. Some locations of artworks are given here for reasons of brevity.

Photo © Antonella865/Dreamstime: p. 21; courtesy Art Revisited: p. 144; photo Tom Betts: p. 154; photo Bibliothèque Nationale de France, Paris: p. 118; photo Michael Bok: p. 57; reproduced by kind permission of CALCOFI (California Cooperative Oceanic Fisheries Investigations) programme: p. 58; © Conceptcafe/Dreamstime: p. 39; courtesy Trevor Day/Reading & Writing for Results: pp. 6, 8, 9, 13, 18, 22, 62, 65, 95, 97, 100, 114 (top), 115, 132, 146; © Dreamstimepoint/Dreamstime: p. 133; © Ermess/Dreamstime: p. 107; photo Bryant Fitch, reproduced courtesy Monterey Public Library (California History Room): p. 86 (left); from Henri Gervais and Raoul Boulart, *Les Poissons: Synonymie – Description – Mœurs – Frai – Pêche – Iconographie . . .*, vol. III: 'Les Poissons de Mer' Partie 2 (Paris, 1877): p. 10; from Conrad Gesner, *Historiae Animalium liber IV, qui est de Piscium et Aquatilium Animantium Natura . . .* (Zürich, 1558): p. 12 (top); from Wilhelm Giesbrecht, 'Pelagische Copepoden', in *Fauna und Flora des Golfes von Neapel und der angrenzenden Meeres-Abschnitte*, vol. XIX, *Die Pelagischen Copepoden* (Leipzig, 1892): pp. 42–3 (photo Biodiversity Heritage Library); from Charles Girard, 'Contributions to the Fauna of Chile' (no loc., n.d.), reprinted from *U.S. Naval Astronomical Expedition to the Southern Hemisphere, during the Years 1849–'50–'51*, vol. II (Washington, DC, 1858): p. 124; photo Carol M. Highsmith: p. 112 (Library of Congress, Washington, DC (Prints and

Photographs Division – Carol M. Highsmith Archive)); photo © Leon Joubert/www.bittenbysharks.com: p. 25; © Georgios Kollidas/Dreamstime: p. 63; from David Kramer, 'Distributional atlas of fish eggs and larvae in the California current region: Pacific sardine, *Sardinops caerulea* (Girard), 1951 through 1966', from California Marine Resources Committee, *calcofi Atlas* (12), 1970: p. 52 (image reproduced by kind permission of calcofi programme); Kunsthaus Zürich: p. 130; photo Library of Congress, Washington, dc (Prints and Photographs Division – Historic American Engineering Record): p. 116; © Lukaves/Dreamstime: p. 16; Captain Frank Manata Collection, Japanese American Citizens League of Monterey: p. 82; photo John Margolies/Library of Congress, Washington dc (Prints and Photographs Division - John Margolies Roadside America photograph archive): p. 99; Metropolitan Museum of Art (Robert Lehman Collection, 1975 – Open Access): p. 140 (top); reproduced courtesy Monterey Public Library (California History Room) [photographer unknown]: p. 86 (right); © Carlos Mora/Dreamstime: p. 135; photo William L. Morgan, reproduced courtesy Monterey Public Library (California History Room): p. 84; from Thomas Moule, *The Heraldry of Fish. Notices of the Principal Families bearing Fish in their Arms* . . . (London, 1842) : p. 73; photos nasa Earth Observatory: p. 45 (image created by Norman Kuring, Ocean Color Web), 160; reproduced courtesy of the artist (NaTalica [Nathalie Alony]): p. 145; photo nd/ Roger Viollet/Getty Images: p. 119; photo Heidi Pedersen (via pexels. com): p. 164; photos © Claudia Pellarini/www.bittenbysharks.com: pp. 24, 28; courtesy of Penlee House Gallery and Museum, Penzance: p. 143 (foot); Dan Pisut/National Oceanic and Atmospheric Administration, Environmental Visualization Laboratory, reproduced courtesy of the Scripps Institution of Oceanography Library: p. 126; from *Popular Science Monthly*, iv/6 (April 1874): p. 114 (middle); photo Andreas Praefcke: p. 140 (foot); Real Academia de Bellas Artes de San Fernando, Madrid: p. 136; courtesy the artist (Ben Rikken): p. 144; © Rixie/Dreamstime: p. 35; photos George Robinson, reproduced courtesy Monterey Public Library (California History Room): pp. 79, 80; photos The St Ives Museum, © Comley Collection: pp. 60, 66, 69, 70, 72 (reproduced by kind permission); photo Dino Sassi - Marcel Fayon, Photo Eden Ltd:

# Index

Page numbers in *italics* refer to illustrations